IOWA a photograph

photography by Clint Farlinger and Mike Whye

FARCOUNTRY

Thanks to Amy and Mark for all your love and support, and for your tolerance of my photography habit. Thanks, too, to Mom and Dad for allowing a fourteen-year-old to buy an expensive camera all those years ago.
—Clint Farlinger

I'd like to dedicate my part of this book to my wife, Dorie Stone, and our three great children, Graham, Meredith, and Alex, for putting up with me during my photographic adventures. —Mike Whye

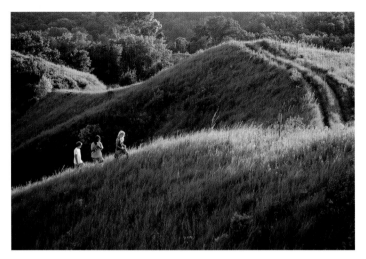

Above: A trio of teens hikes a Loess Hills slope in the 1,268-acre Hitchcock Nature Center north of Crescent. When explorers Meriwether Lewis and William Clark visited this area in 1804, they wrote of the "bald-pated" hills, meaning they were covered with prairie. Trees have overtaken many of these "bald" hills since then. Mike Whye

Right: This bird's-eye view of the rolling hills of Winneshiek County shows an otherwise unnoticeable damask stripe pattern in the green fields. Clint Farlinger

Title page: A tour boat cruises along the Mississippi River near Dubuque on a summer evening. Mike Whye

Front cover: Early autumn tints the countryside along the Driftless Area Scenic Byway near Churchtown. Clint Farlinger

Back cover: Canada geese wing their way into the sunset over central Iowa. Mike Whye

ISBN: 978-1-56037-633-0

© 2015 by Farcountry Press
Photography © 2015 by Clint Farlinger
Photography © 2015 by Mike Whye

For more information about our books, write Farcountry Press, P.O. Box 5630, Helena, MT 59604; call (800) 821-3874; or visit www.farcountrypress.com.

Produced in the United States of America.
Printed in China.

19 18 17 16 15 1 2 3 4 5 6

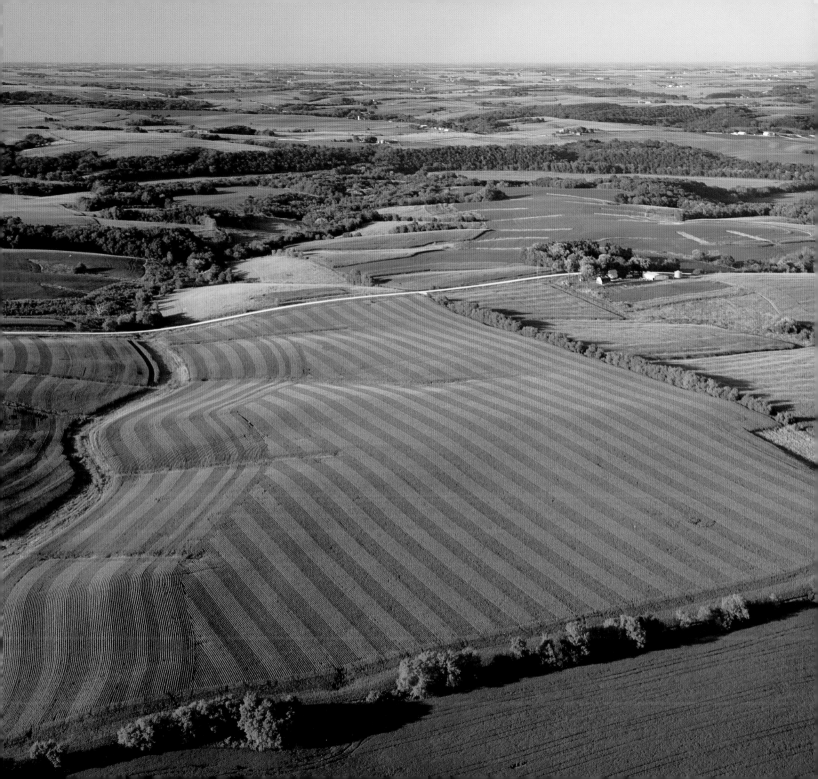

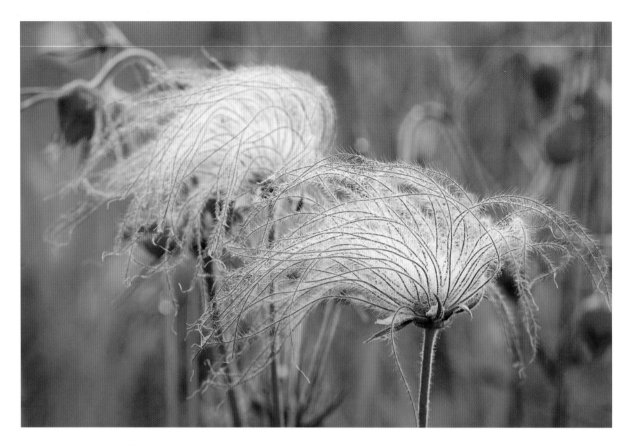

Above: Prairie smoke is one of the first species to blossom in the spring on Iowa's prairies. These "old man's whiskers" bloom annually at Hayden Prairie State Preserve south of Chester. Clint Farlinger

Right: An autumn rain falls upon grapes about to be harvested at Sugar Clay Winery in the Loess Hills near Thurman. Because of its tendency to erode easily in rain, loess soil is known locally as "sugar clay." Mike Whye

Facing page: Saint John's Evangelical Lutheran Church of Winneshiek County, about five miles southwest of Ridgeway, was founded in 1859 to serve the German immigrant population there. The ruins of Saint John's building are known today as "The Old Stone Church," and were constructed using local limestone. Clint Farlinger

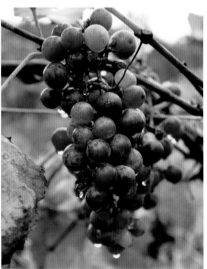

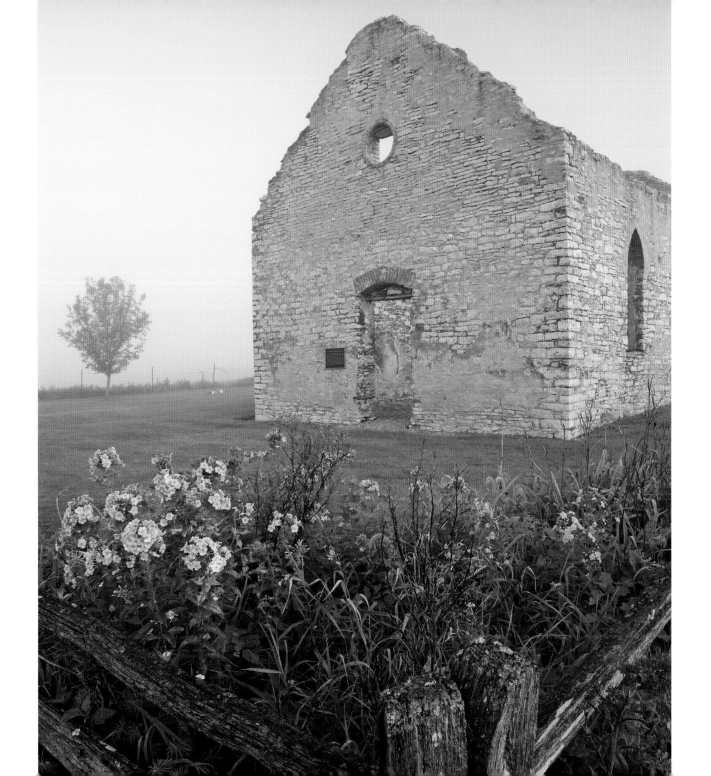

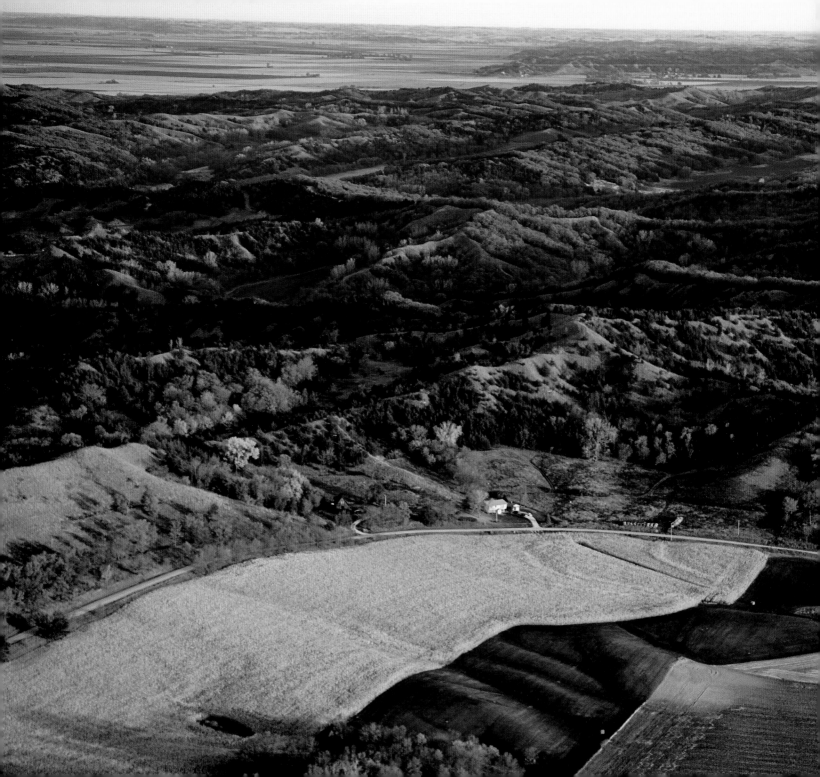

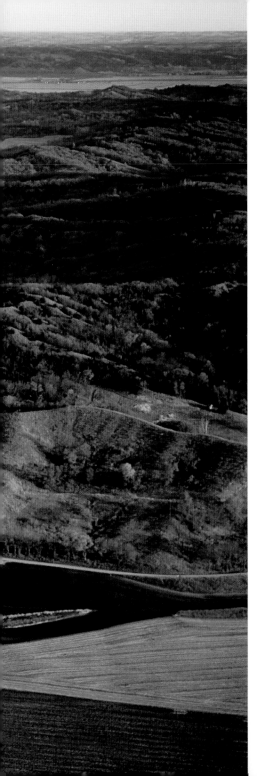

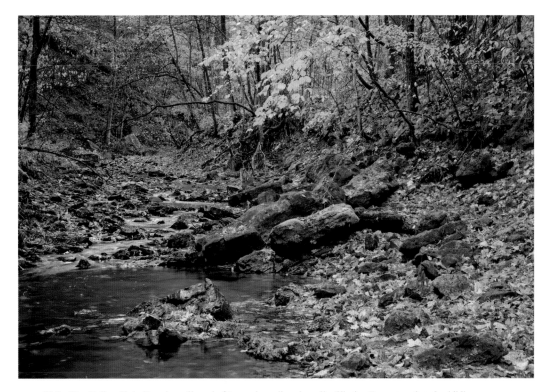

Above: White Pine Hollow State Forest, northwest of Luxemburg, lies along the Silurian Escarpment and exhibits a varied terrain, from rock outcroppings and cliffs, to caves, springs, and steep-walled canyons. More than 500 species of vascular plants live in the preserve. About 400 acres of the preserve is old-growth forest, making it the largest old-growth forest in Iowa and truly one of Iowa's greatest natural places. Clint Farlinger

Left: The Loess Hills of Monona County look impressive from above, and it's easy to imagine the windblown soil drifting like snow over the landscape to form these marvelous dune-like shapes. Clint Farlinger

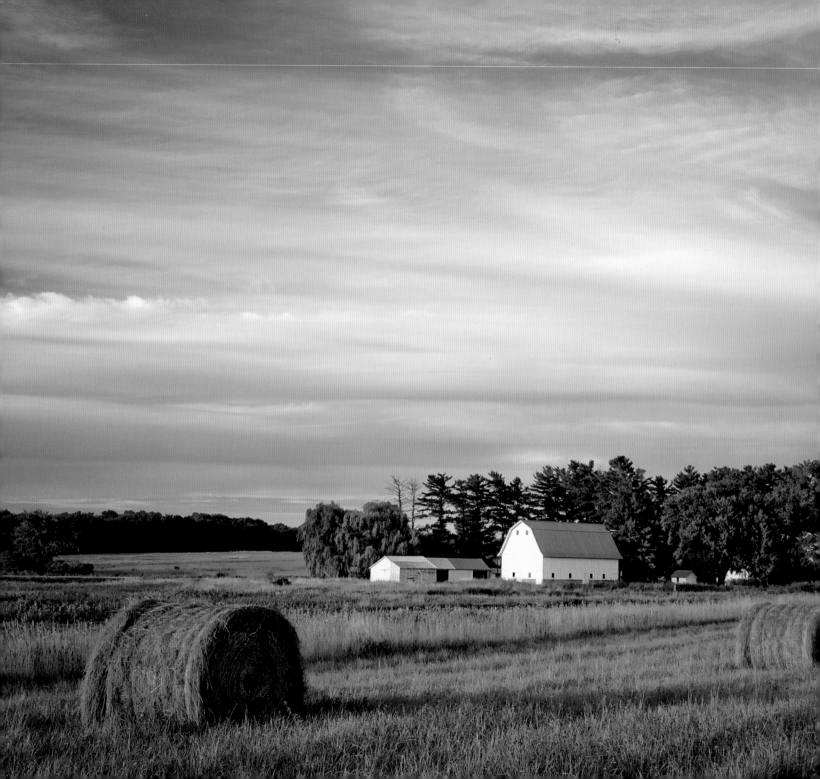

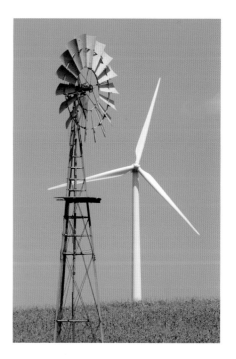

Left: Round hay bales mark the rich fields of the Norman Borlaug Birthplace Farm. Clint Farlinger

Right: Representing two eras upon the Great Plains, an older windmill draws water from aquifers deep below, while a newer model snares the wind to create electricity. Iowa leads the nation in the percentage of electricity generated by wind. Mike Whye

Below: Created by artist Deborah Butterfield, *Ancient Forest* is made of bronze castings of driftwood gathered by the artist. *Ancient Forest* is one of 28 works of art featured in the 4.4-acre John and Mary Pappajohn Sculpture Garden in downtown Des Moines. Mike Whye

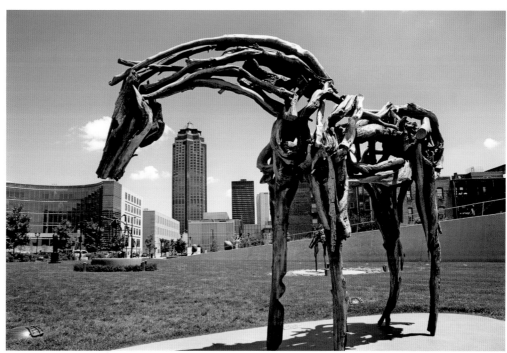

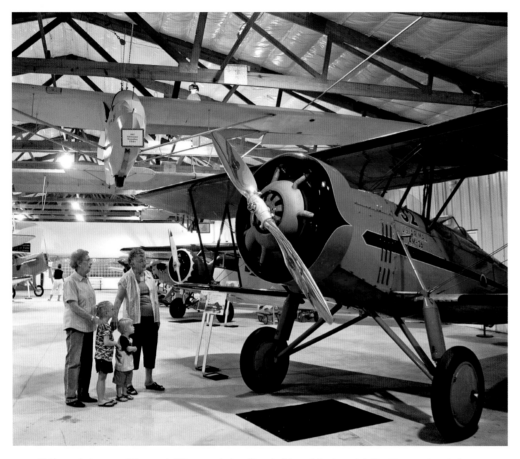

Above: Visitors admire one of the nearly 20 powered aircraft and gliders at the Iowa Aviation Museum. Located at the airport north of Greenfield, the museum also contains the Iowa Aviation Hall of Fame. Its aircraft range from the one-and-only Aetna-Timm Aerocraft trainer to the more common Piper J-2. Mike Whye

Right: Artillery troops fire their cannon during a re-creation of a battle during Mason City's Civil War Reenactment. An annual event since the 1990s, the reenactment demonstrates action between Confederate and Union troops, plus quiet times in their authentic encampments. Mike Whye

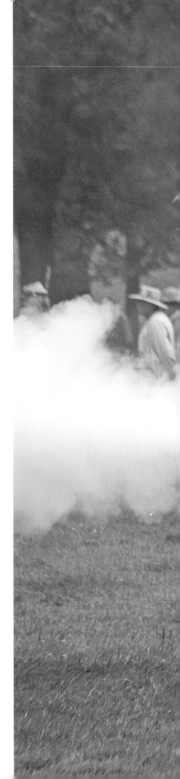

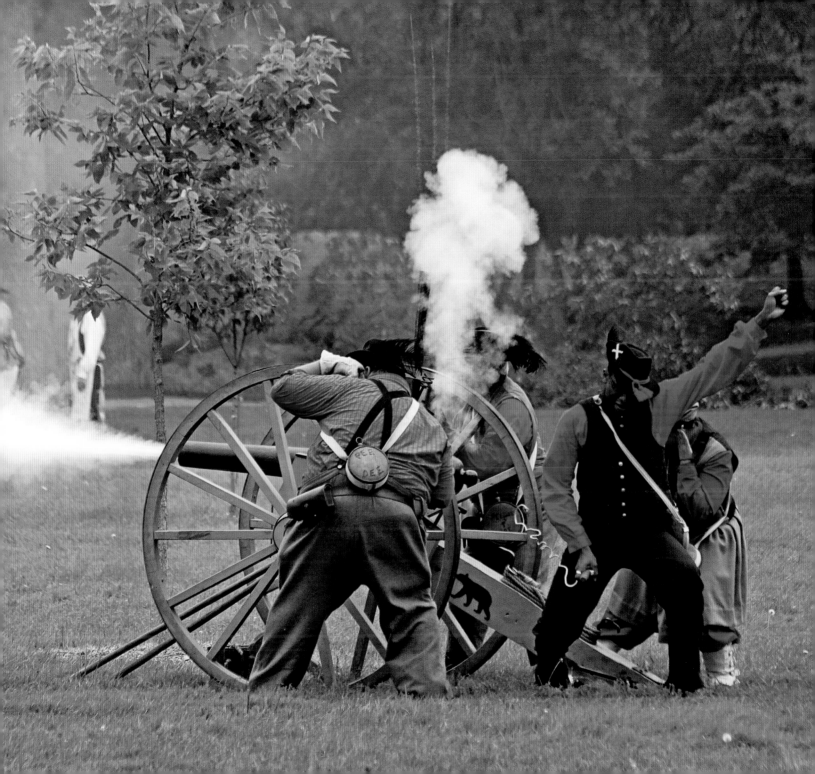

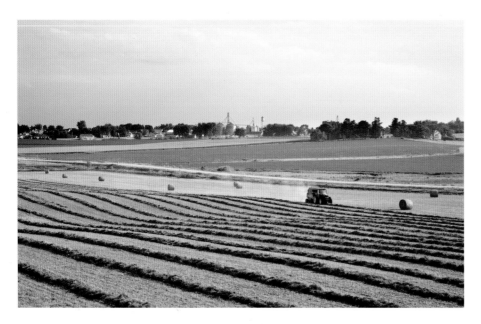

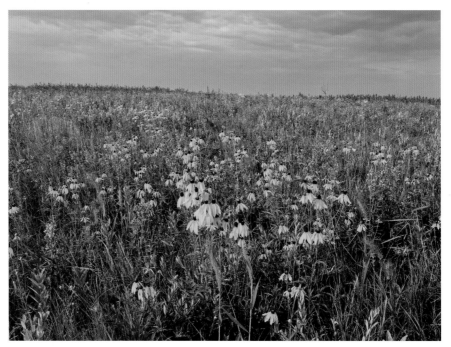

Above: This farmer is literally "making hay while the sun shines," with the town of Ridgeway visible in the distance. Clint Farlinger

Right: Hayden Prairie State Preserve, three miles south of Chester, has been described as a true prairie remnant, and it was recognized as a National Natural Landmark in 1965. Yellow coneflower and showy tick trefoil are only 2 of the more than 200 plant species, 46 bird species, and 20 butterfly species that make their home in Hayden Prairie. Clint Farlinger

Far right: Bicyclists stream across central Iowa while participating in RAGBRAI, which has rolled across Iowa each July since it was founded by the *Des Moines Register* newspaper in 1973. The *Register's* Annual Great Bike Ride Across Iowa is touted as the world's longest, largest, and oldest bicycle touring event.
Mike Whye

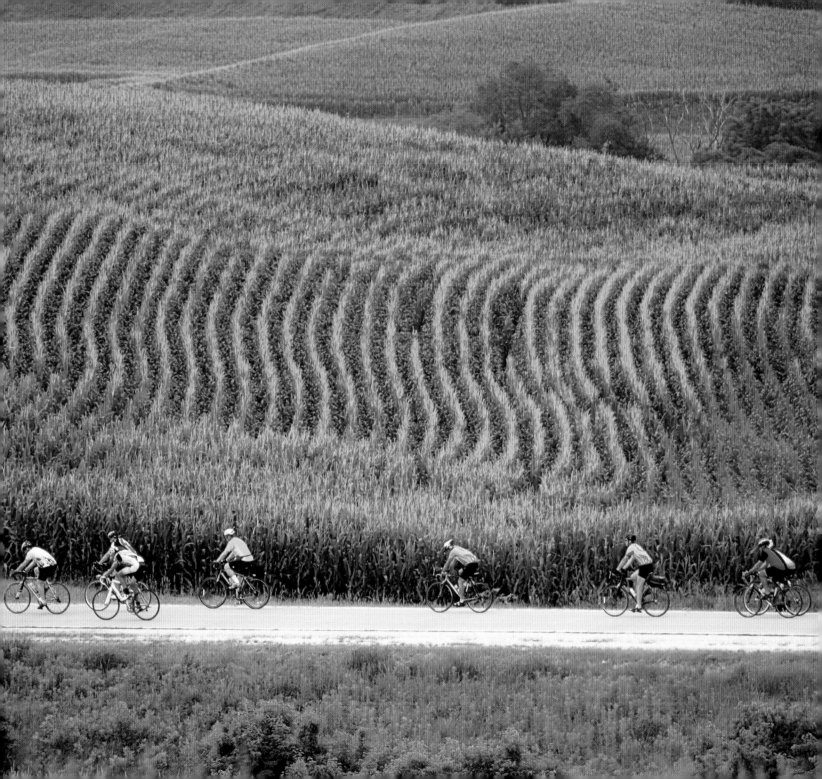

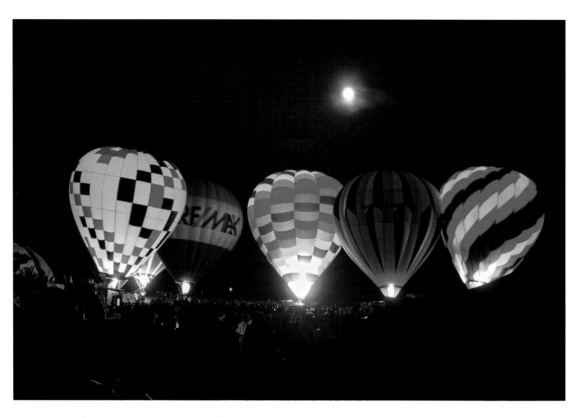

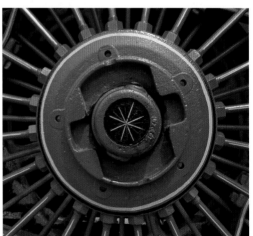

Above: Hot air balloons glow brilliantly during a moonlit Fields of Flight event at Ditmar's Orchard, a short distance northeast of Council Bluffs. Mike Whye

Left: Bright colors adorn the steel wheel of an antique steam-powered tractor participating in a tractor contest near Cedar Falls. Mike Whye

Right: The midway at the Mighty Howard County Fair attracts young and old alike during fair week. Clint Farlinger

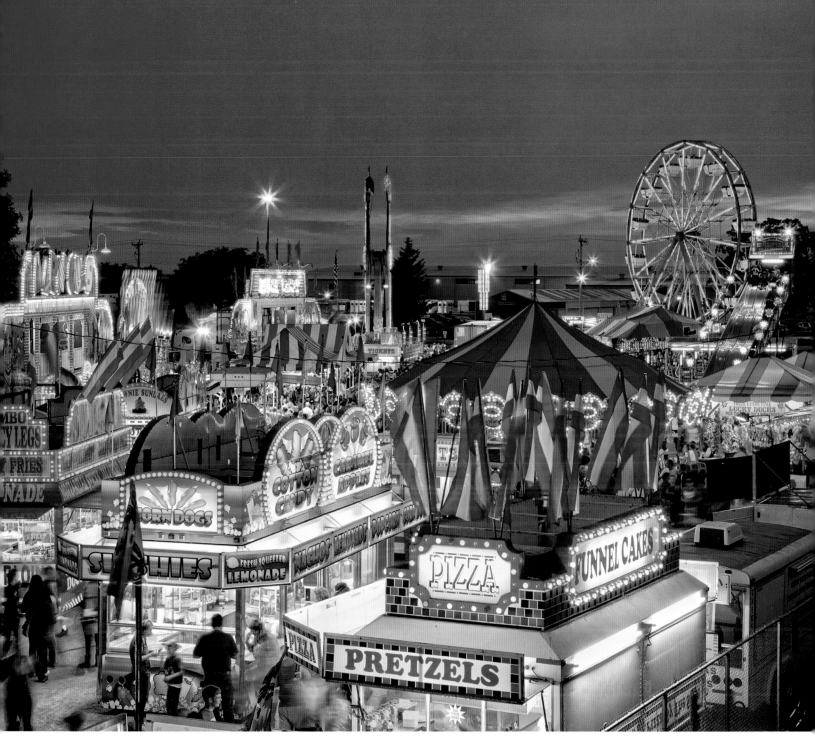

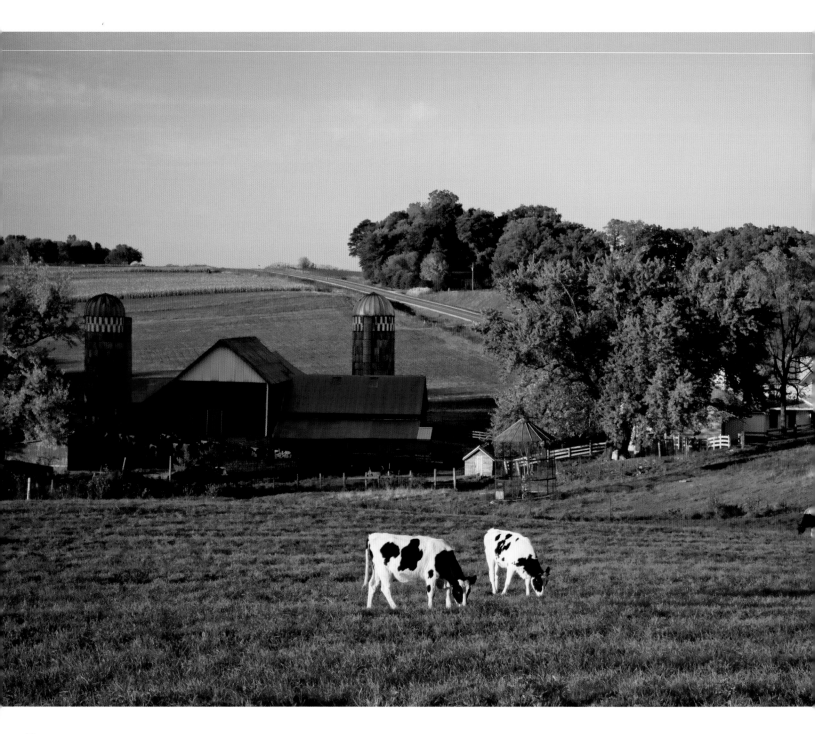

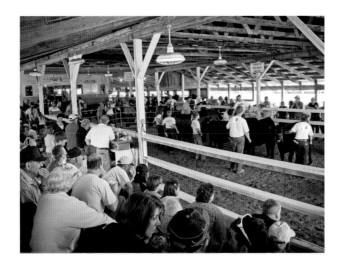

Far left: Holstein cows graze upon lush grasses on a tranquil late summer evening near Florenceville. Clint Farlinger

Left: At the state's many beloved county fairs, 4-H livestock judging always draws a crowd. Thousands of Iowa youths participate in 4-H clubs, which offer programs spanning a wide array of topics, including livestock, healthy living, public speaking, and creative arts. Clint Farlinger

Below: An Amish buggy on a gravel road is a familiar rural scene in northern Howard County. More than 7,000 Amish people live in settlements large and small across Iowa. Clint Farlinger

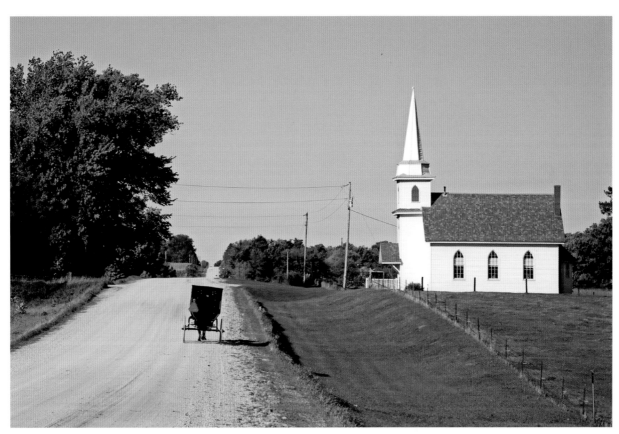

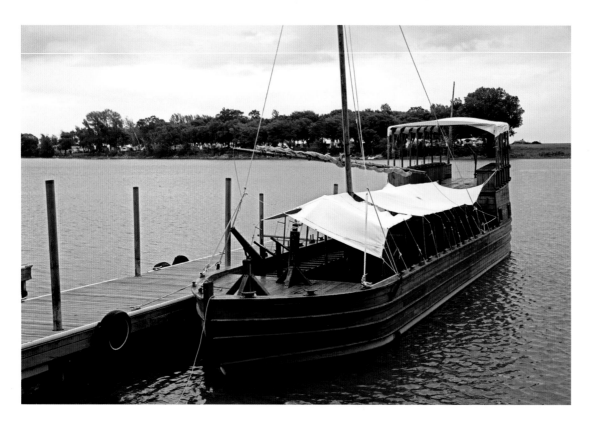

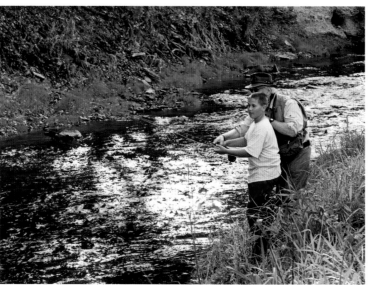

Above: A replica of the keelboat used by explorers Lewis and Clark sits at its dock alongside Blue Lake in Lewis and Clark State Park near Onawa. The original boat was pushed, pulled, sailed, and rowed as the Corps of Discovery made its way up the Missouri River in 1804. Mike Whye

Right: The cool, swift creeks of northeastern Iowa, such as Coldwater Creek shown here, boast excellent trout fishing and peaceful family time as angling skills are passed from generation to generation. Clint Farlinger

Far right: The Upper Iowa River is considered one of the premier canoeing and kayaking locations in the country. Paddlers on the Upper Iowa are treated not only to scenic bluffs, but also to bald eagles, herons, beavers, and occasional schools of fish. Clint Farlinger

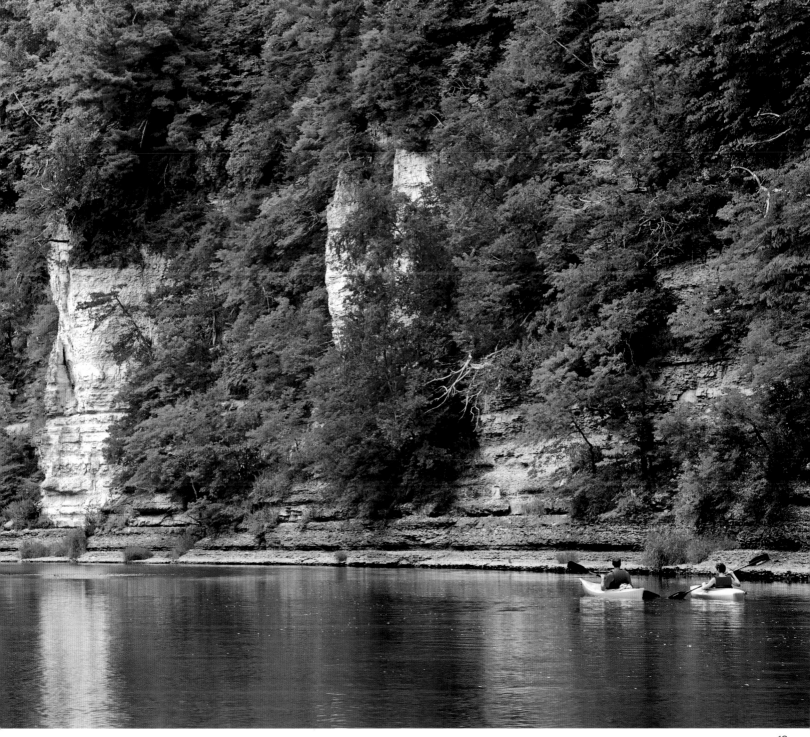

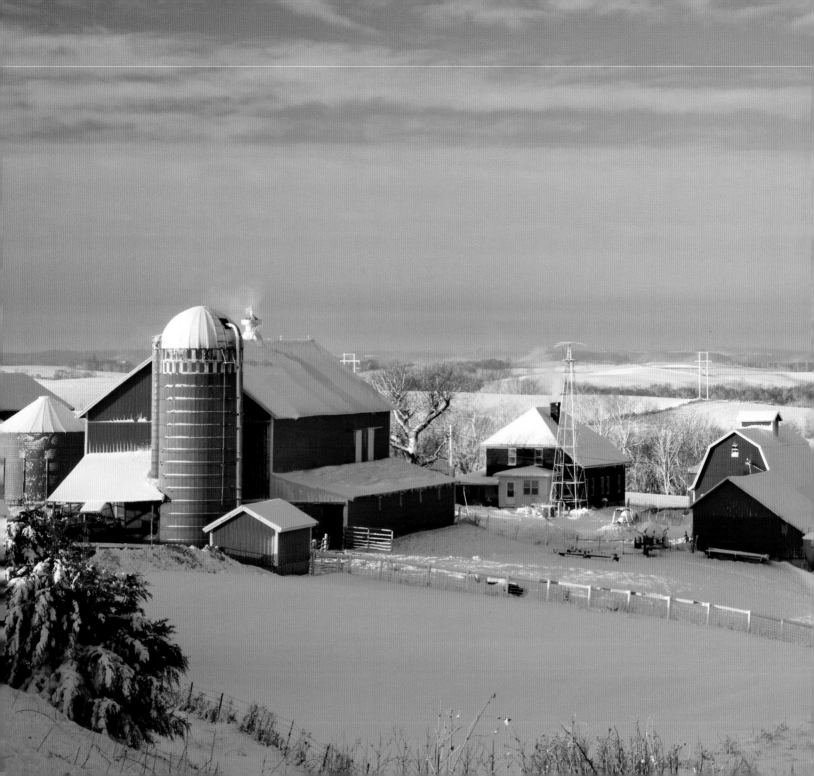

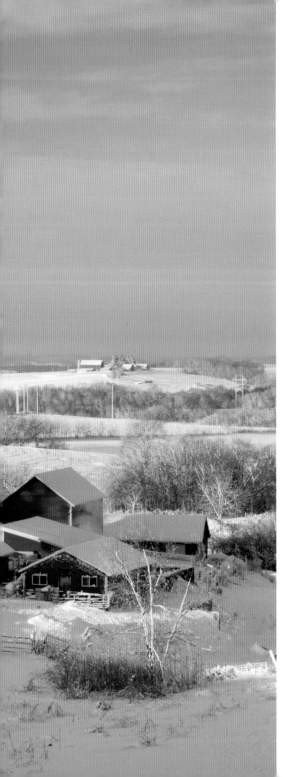

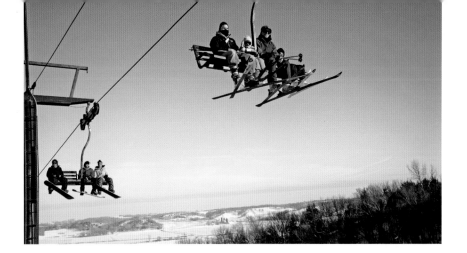

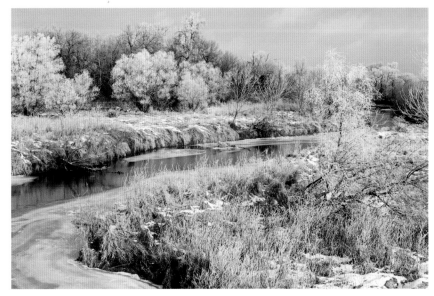

Above, top: Downhill skiers ride the lift to the upper reaches of Mount Crescent, a ski resort located in the Loess Hills just north of the town of Crescent. Iowa, despite its reputation for flatness, boasts several ski areas perfect for a thrill on a winter day. Mike Whye

Above, bottom: Seen here in Chickasaw County near Alta Vista, the Wapsipinicon River is a tributary of the Mississippi River that meanders 300 miles through northeastern Iowa. One explanation for the name centers on Native American lovers Wapsi, a Meskwaki maiden, and Pinicon, a Sac warrior, who tragically drowned together in the flowing waters. According to the legends, their names were combined to give the river its name and commemorate the tragic event. Clint Farlinger

Left: This picturesque farm is located along the 109-mile River Bluffs Scenic Byway. The Byway traverses northeastern Iowa, a distinctive region marked by rolling hills and valleys, towering bluffs, and luxurious green landscapes that paint the countryside as far as the eye can see. Clint Farlinger

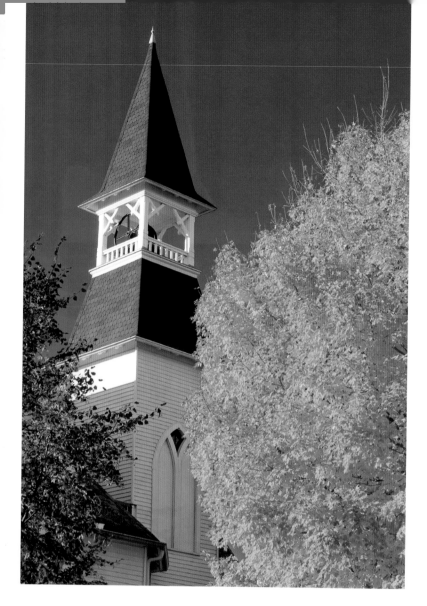

Left: A brilliantly colored maple tree frames the steeple of First Baptist Church in Osage, appropriately nicknamed the "City of Maples."
Clint Farlinger

Right: Sunset isn't enough to slow down this Osage area farmer during planting season.
Clint Farlinger

Below: Northwest of Iowa City, Williams Prairie Preserve is a biologically important wet prairie featuring diverse species such as these fragrant coneflowers. The preserve is one of 30 in Iowa managed by The Nature Conservancy.
Clint Farlinger

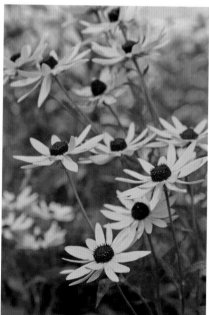

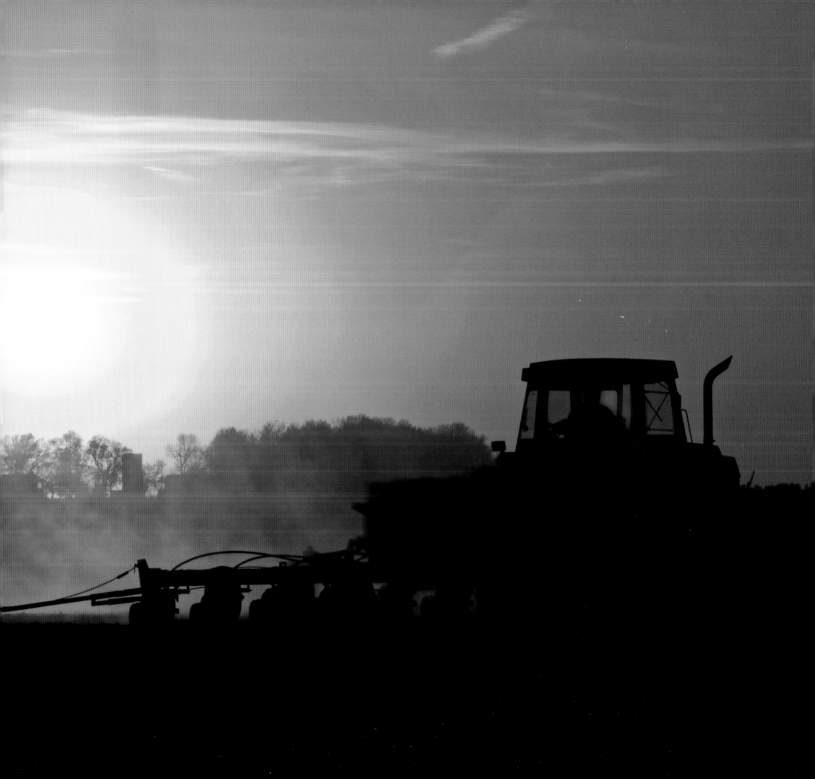

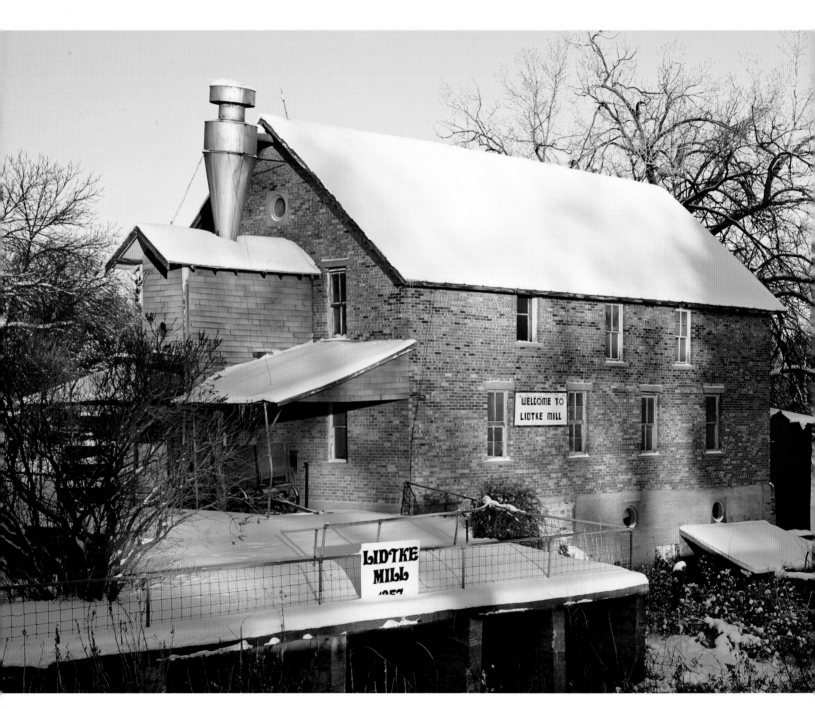

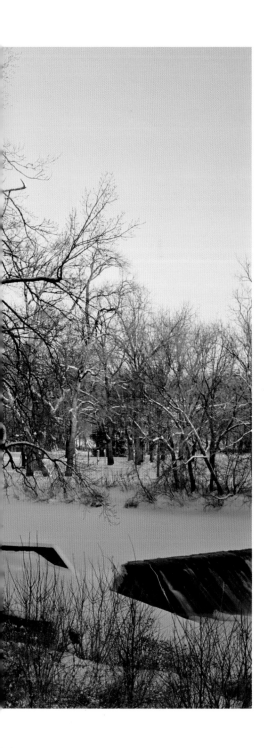

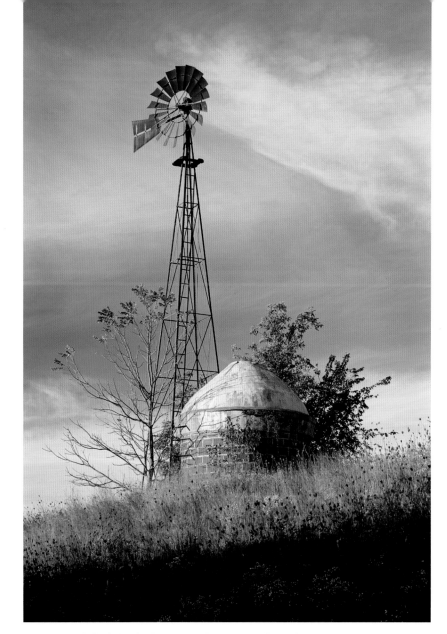

Above: The windmill of historic Skuster Farm stands as a reminder of days gone by near Charles City. Clint Farlinger

Left: Built in 1857 as a timber-cutting mill, Lidtke Mill was later sold, enlarged, and converted to grind wheat flour. During its peak, the mill operated day and night in order to supply flour to the eastern United States and Europe. The fully intact, working mill stands just north of Lime Springs along the Upper Iowa River. Clint Farlinger

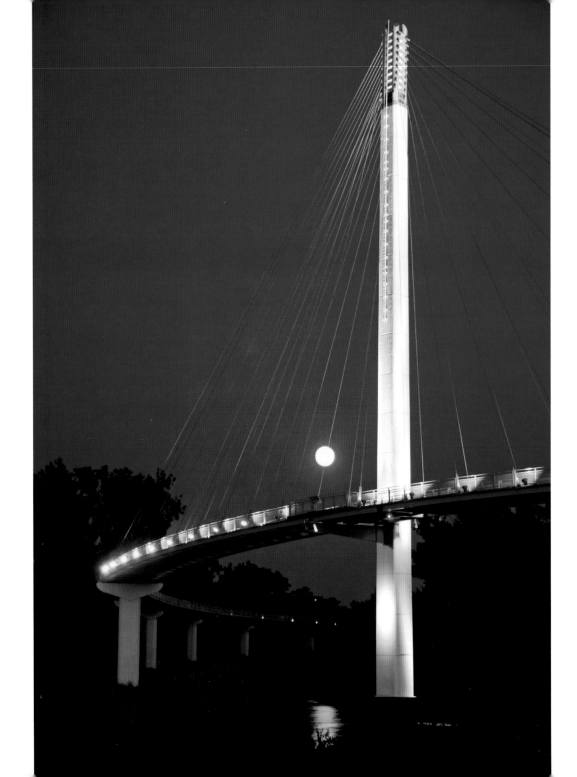

Facing page: The moon rises over one end of the Bob Kerrey Pedestrian Bridge, which links Council Bluffs to Omaha, Nebraska, across the Missouri River. About 3,000 feet long, it's the longest interstate pedestrian bridge in the nation, and lights atop its towers change colors at night. Mike Whye

Left: The stainless steel forms of a guitar and three records, sculpted by Ken Paquette, mark where a plane crashed on the night of Feb. 3, 1959, killing musicians Buddy Holly, Ritchie Valens, and J. P. "The Big Bopper" Richardson, an event immortalized by Don McLean in his song "American Pie." Mike Whye

Below: A pleasure boat speeds across the waters of West Lake Okoboji against a backdrop formed by the popular amusement park in the community of Arnolds Park. The park's first attraction was built in 1889, and the current wooden roller coaster, Legend, was built in 1930. Mike Whye

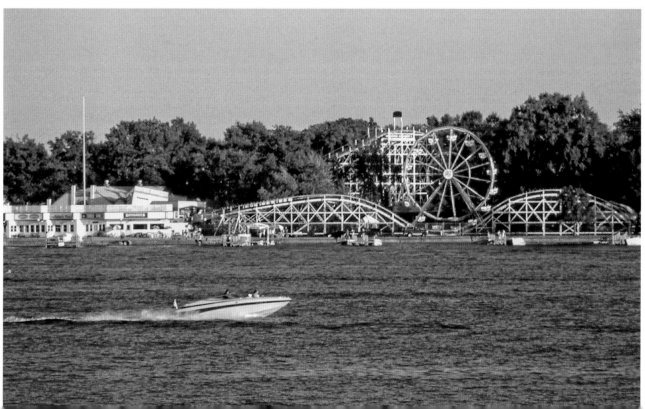

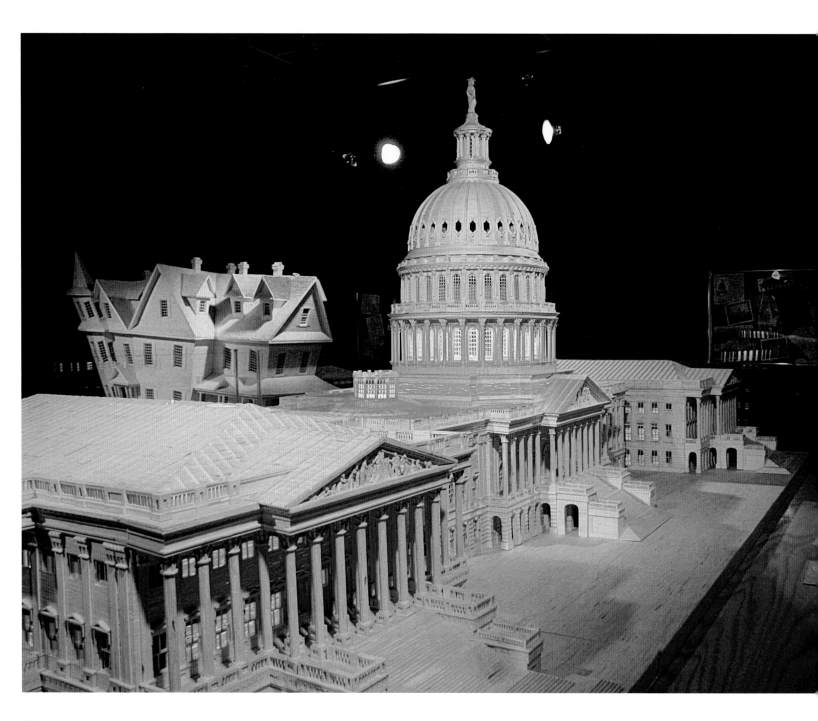

Left: A model of the U.S. Capitol presides over Matchstick Marvels in downtown Gladbrook. Its creator, Patrick Acton, uses matchsticks to make creations ranging from country schools to the battleship USS Iowa and from the Iowa governor's mansion to the International Space Station. The 12-foot-long capitol model required 478,000 matchsticks, making it among the largest of Acton's models. Mike Whye

Below, left: This wetland along Round Lake in Harrison County, north of Mondamin, is one of many found in the alluvial plain of the Missouri River. Late evening light accentuates the gold, orange, and yellow hues of this autumn scene. Clint Farlinger

Below, right: Saint Joseph Catholic Church, nestled in the town of Elkader, was constructed in 1898 in the Victorian Gothic design using stone native to the area. Clint Farlinger

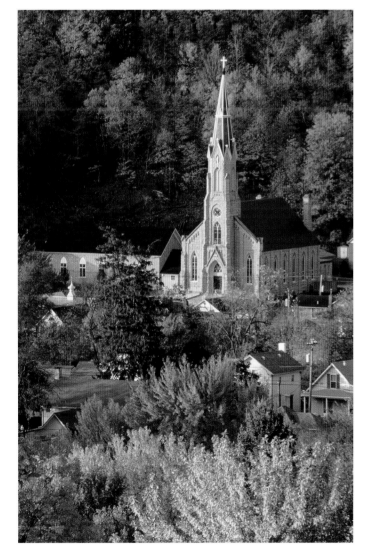

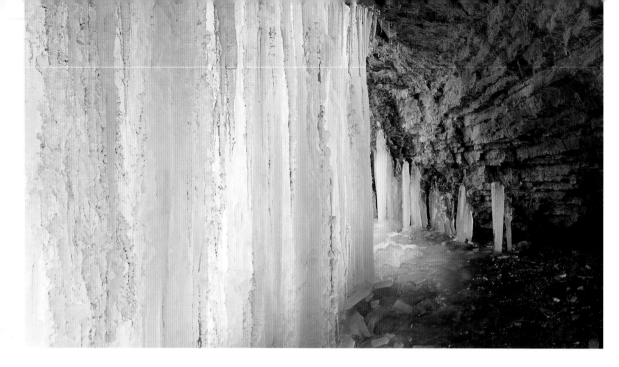

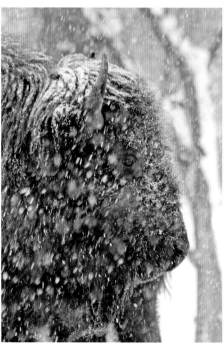

Above: Waterfalls are a rarity in most of Iowa, but the rugged topography and limestone bluffs of northeastern Iowa's Driftless Area are home to several, including Bridal Veil Falls in Pikes Peak State Park near McGregor. Clint Farlinger

Right: Sprinkled by a light snow, a stalwart bison, also called buffalo, endures the onset of another Iowa winter. This animal's ancestors once lived by the millions on the Great Plains. Mike Whye

Far right: Richmond Springs, one of Iowa's largest springs, lies entirely within Backbone State Park. Dedicated in 1920, Backbone was Iowa's first state park. It boasts thick forests, picturesque rock outcroppings, and the park's namesake: a narrow, steep ridge of bedrock carved by the Maquoketa River and called "Devil's Backbone." Clint Farlinger

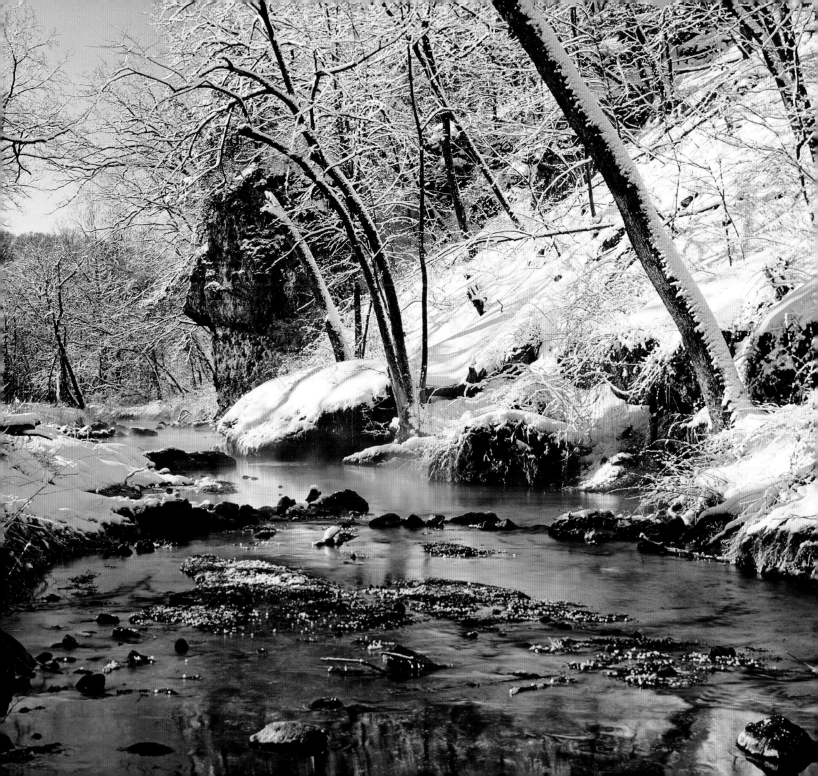

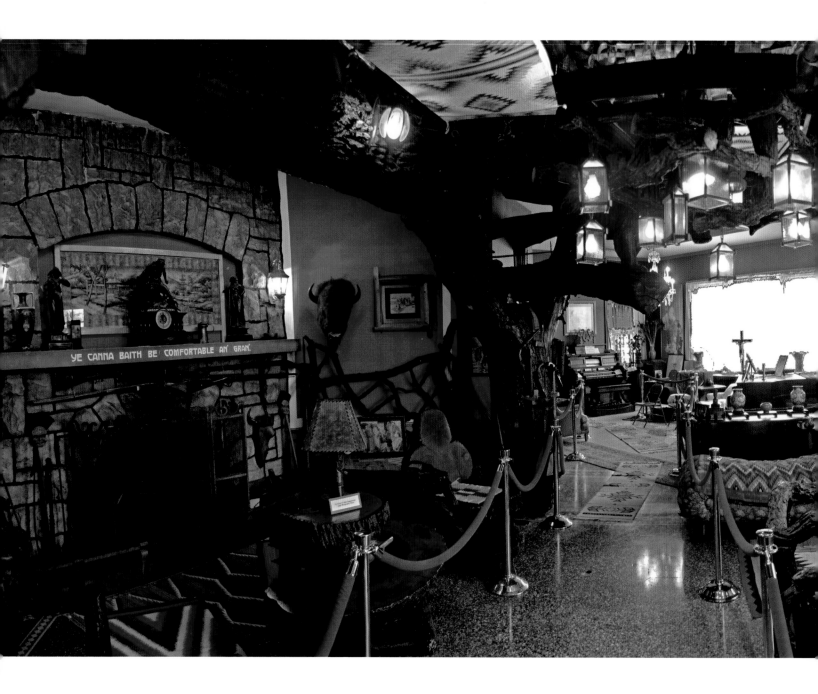

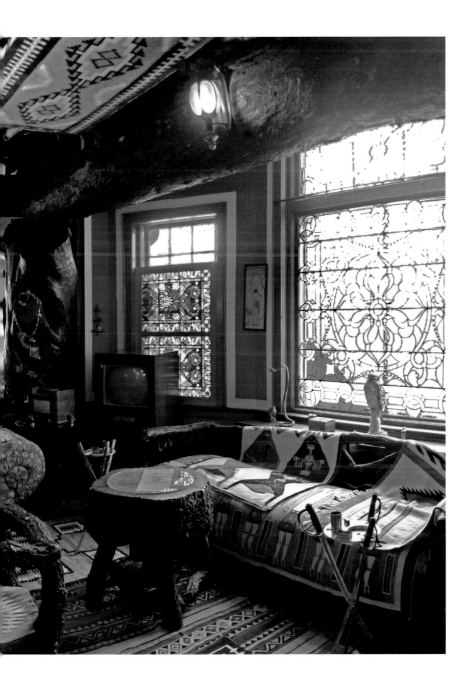

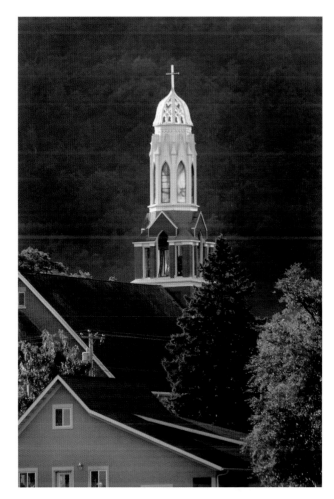

Above: Backlit by the late afternoon sun, the steeple of St. Joseph's Catholic Church glows against a wooded hill behind New Albin. Built in 1910, St. Joseph's has a bell from the congregation's previous church, a wood frame building that once stood nearby. Mike Whye

Left: Open to the public, the Palmer Family Residence in Davenport displays eclectic artifacts collected around the world by B. J. and Mabel Palmer. The house is on the campus of Palmer College of Chiropractic, founded by B. J.'s father, Daniel David Palmer, in 1897. Mike Whye

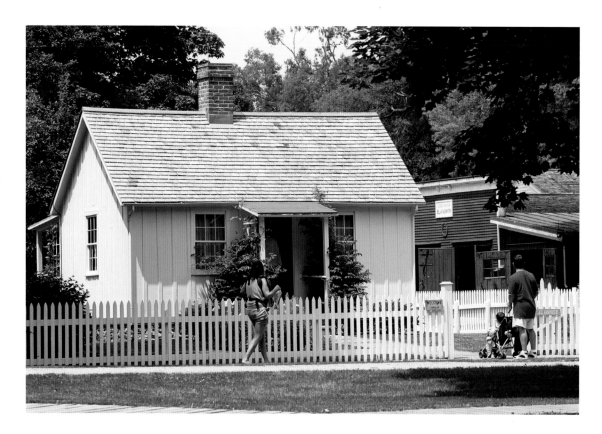

Above: A stone's throw from his father's blacksmith shop in West Branch, the small cottage where Herbert Hoover was born is maintained by the National Park Service as it was when he was born in 1874. Hoover, the 31st U.S. president (1929-1933), was the first president born west of the Mississippi River. Mike Whye

Right: The bronze copper butterfly normally likes to hide out on low branches and leaves, but when good nectar sources, such as swamp milkweed, are present, it will spend the day enjoying an extended lunch. This butterfly café was found in Davis Wetland, Monona County, east of Onawa. Clint Farlinger

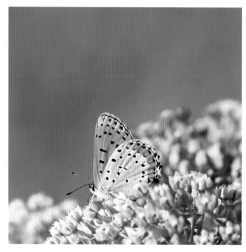

Far right: When a resident of Burlington saw the five half curves and two quarter curves on North Sixth Street, he nicknamed the stretch Snake Alley and the name has stuck. Its design made it easier for horse-drawn vehicles to navigate the slope between downtown and a shopping area atop a steep hill. Mike Whye

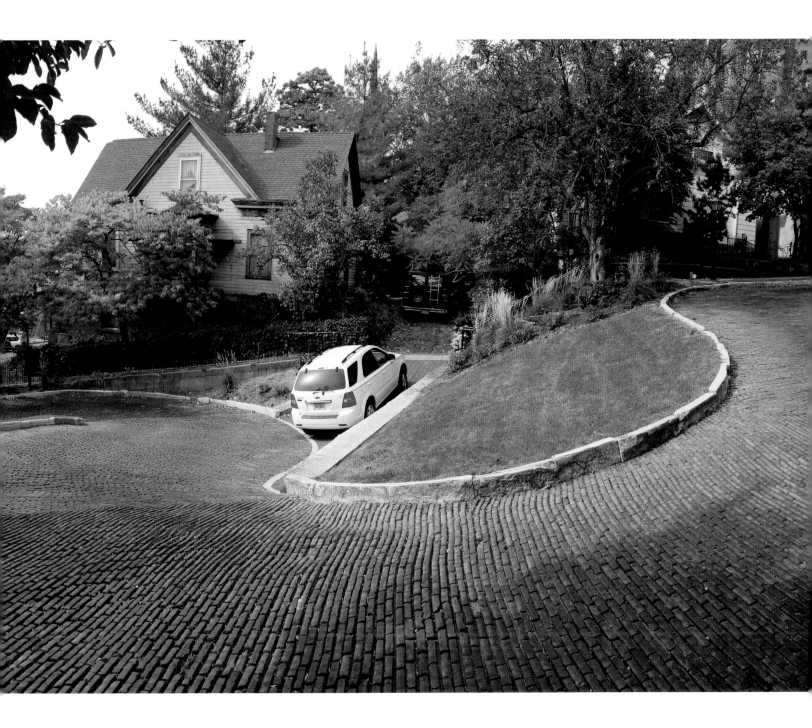

Above: Northern red oak leaves glow in early morning light at Woodthrush Woods State Preserve, between Fairfield and Lockridge. In 1961, the Iowa General Assembly designated the "oak" as Iowa's official state tree. No specific species was named, making all 12 species of oak trees native to Iowa the state tree!
Clint Farlinger

Right: Visitors frequently pose, sporting clothes and a pitchfork provided by the visitor center, in front of the house in Eldon that Grant Wood used as the background for his most famous painting, *American Gothic*. The State Historical Society of Iowa now maintains The American Gothic House. Mike Whye

Far right: Regionalist artist Grant Wood (1891-1941), used this upper level of a carriage house at 5 Turner Alley in Cedar Rapids as his residence and studio from 1924 to 1935. He shared this simple residence with his sister Nan, who modeled as the woman in *American Gothic*, and their mother. Mike Whye

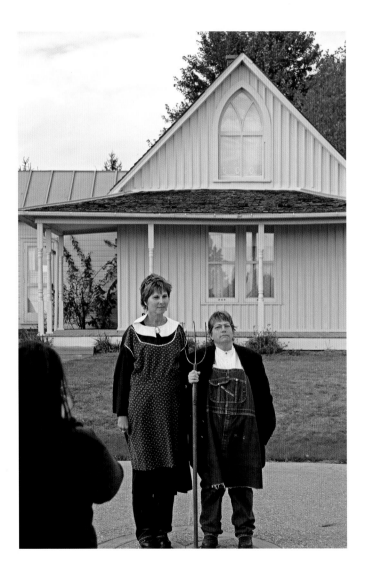

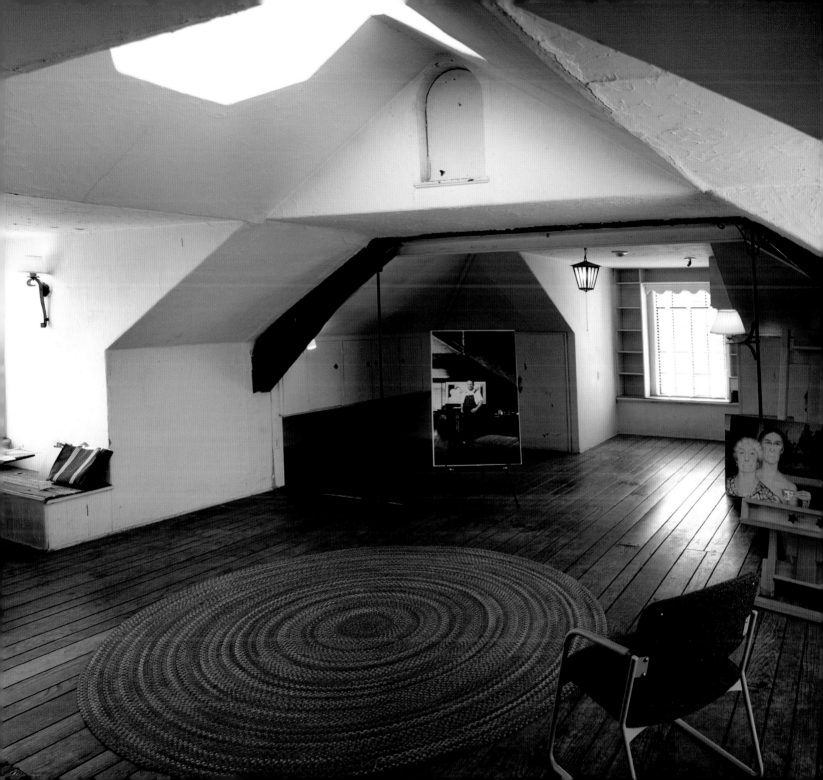

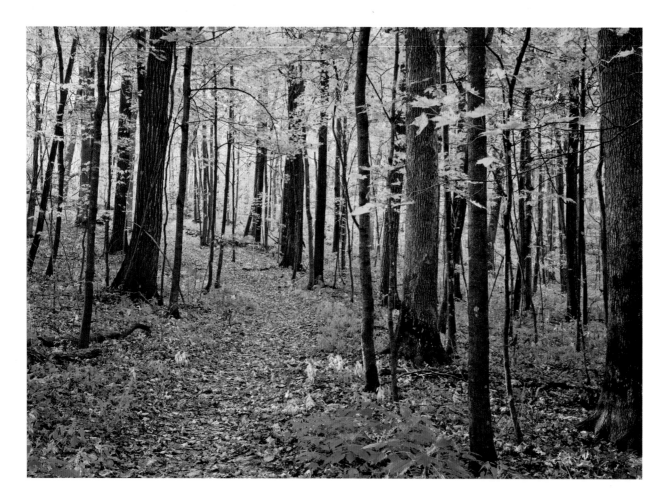

Above: Ash Trail meanders through the Paint Creek Unit of Yellow River State Forest west of Harpers Ferry, and has helped this forest earn the reputation of having some of the best hiking in Iowa. Clint Farlinger

Right: Viceroy and monarch butterflies feed on nodding bur marigold at the Fred Maytag II Family Preserve in Muscatine County. Viceroys and monarchs are an excellent example of Müllerian mimicry, a natural phenomenon in which two or more toxic species mimic each other's warning signals—in this case, vibrant orange and black wings—to mutual benefit. Clint Farlinger

Facing page: Ledges State Park, about four miles south of Boone, is one of Iowa's first and most popular parks. Thirteen miles of trails give visitors the opportunity to hike up and down steep slopes leading to scenic overlooks or to enjoy a peaceful, easy stroll around Lost Lake. Clint Farlinger

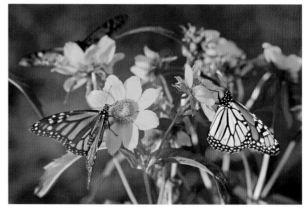

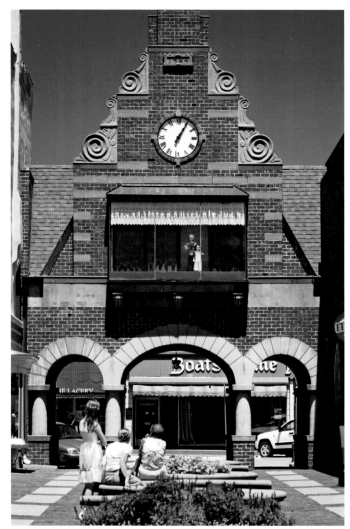

Above, left: Riverside Park in Charles City is a nice place to amble beside the Cedar River, have a picnic, or simply savor the sight and aroma of a flowering crabapple tree in spring. Clint Farlinger

Above, right: At the Klokkenspel in downtown Pella, four-foot-high wooden figures depicting people from the city's past parade singly or in pairs for visitors. Dutch immigrants founded Pella in 1847, and the architecture of many buildings reflects the community's Dutch heritage. Mike Whye

Right: A pleasant evening brings people out for a stroll along Dubuque's half-mile-long Mississippi Riverwalk, which features public art, plazas for events, riverboat moorings, a resort with a waterpark, a convention center, and more. The National Mississippi River Museum and Aquarium are nearby. Mike Whye

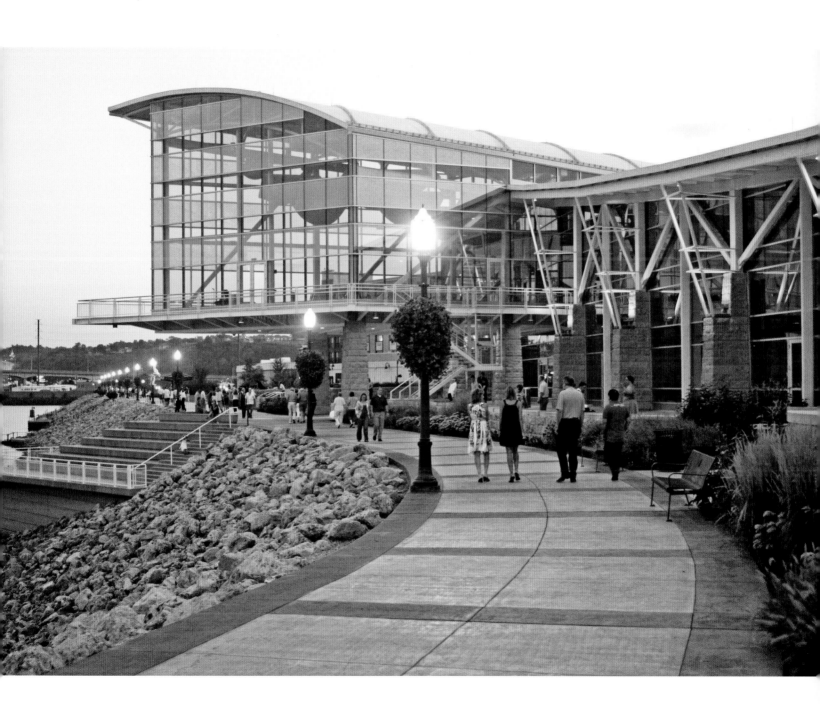

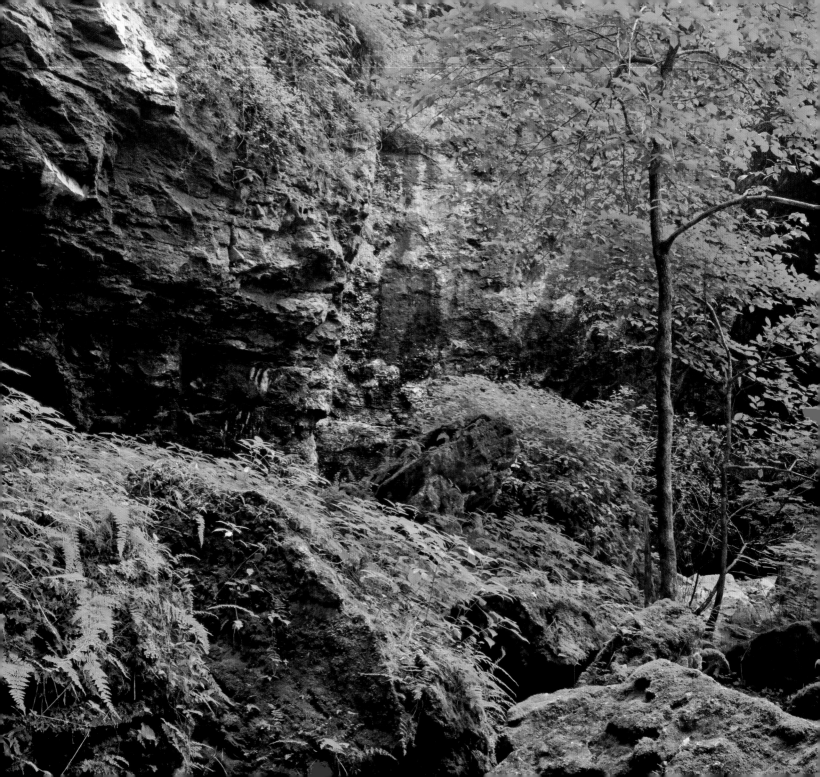

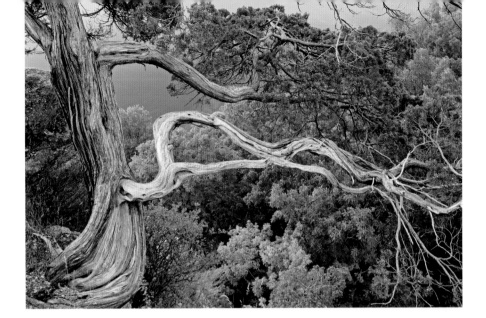

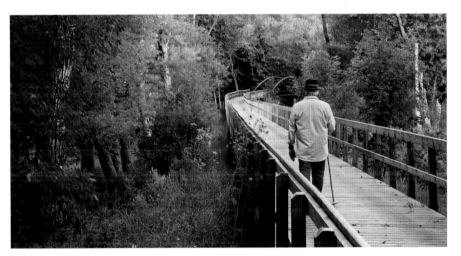

Above, top: This juniper tree clings to a limestone bluff above the Mississippi River in Effigy Mounds National Monument near Marquette. Clint Farlinger

Above, bottom: In addition to its namesake mounds and stunning views of the Mississippi River, Effigy Mounds National Monument preserves wetlands associated with the Yellow and Mississippi Rivers. The Yellow River Bridge Trail is an accessible half-mile trail that allows visitors to explore the wetland environment. Clint Farlinger

Left: The caves, limestone formations, and rugged bluffs of Maquoketa Caves State Park provide visitors a chance to step back through thousands of years of geological time. Caves vary from small Dugout Cave to the 1,100-foot-long Dancehall Cave, complete with walkways and a lighting system. Clint Farlinger

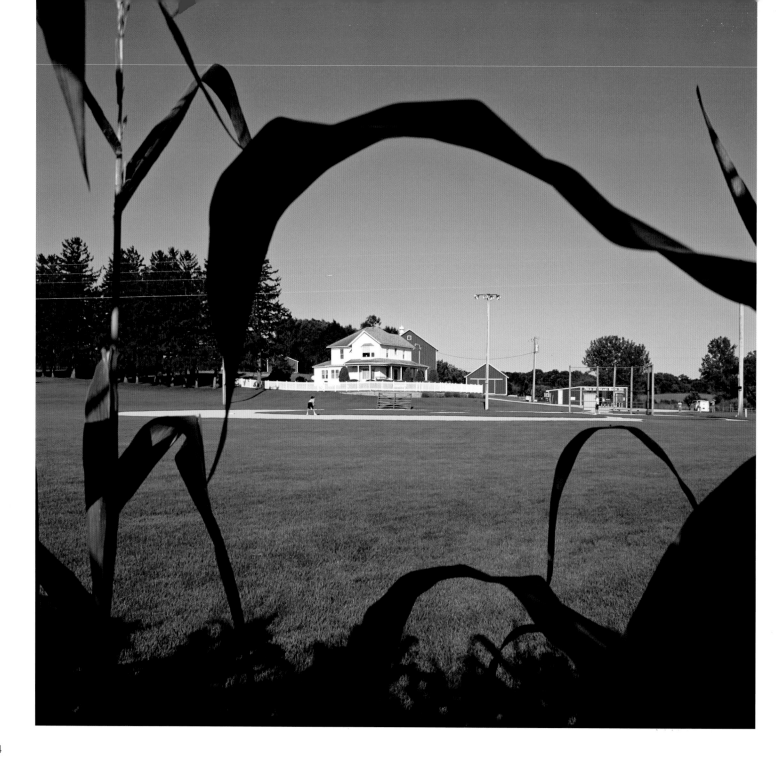

Facing page: Created out of farmland specifically for the movie *Field of Dreams*, the Field of Dreams Movie Site remains popular with visitors, who come from across the world to play baseball here, a few miles northeast of Dyersville. Mike Whye

Below, left: Weighing in at 45 tons of concrete and steel and standing 35 feet tall, Albert the Bull is a monument to the beef industry in Audubon County. Covered with 65 gallons of paint, this Hereford is claimed to be the largest bull in the world. Mike Whye

Below, right: A young man and woman try their luck at fishing in a backwater of the Mississippi River near New Albin, the northeastern-most community in Iowa. Mike Whye

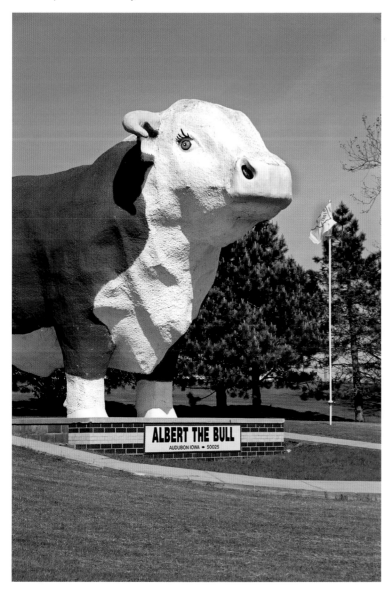

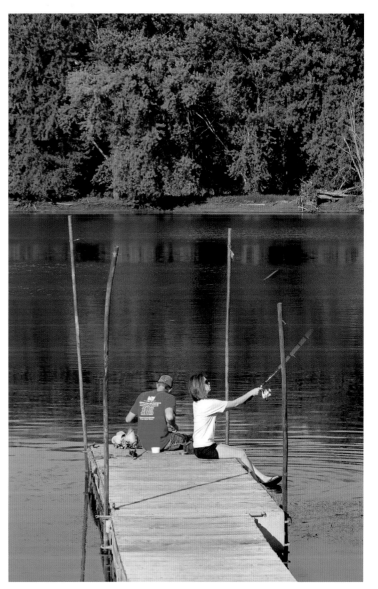

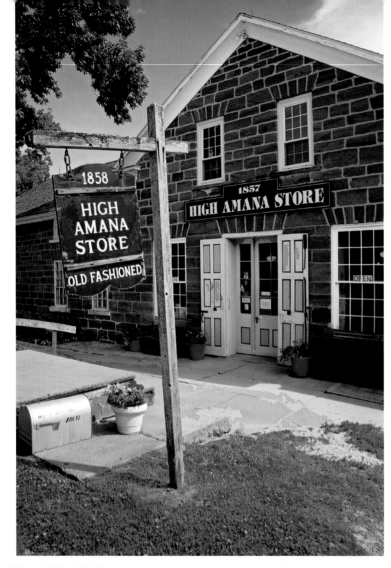

Above: Built in 1857, this general store provided goods to those in High Amana, one of seven communities formed in the nineteenth century by members of the Community of True Inspiration, who immigrated from Germany for religious freedom. Not to be confused with the Amish, the Amana Colonies are popular for high-quality handmade items and restaurants serving family-style meals. Mike Whye

Right: In 1892, American artist Karl Gerhardt sculpted this trio of figures—depicting a Native American guiding a pioneer and his son across the plains of Iowa—to stand in front of the Iowa Capitol, where they look over downtown Des Moines. Mike Whye

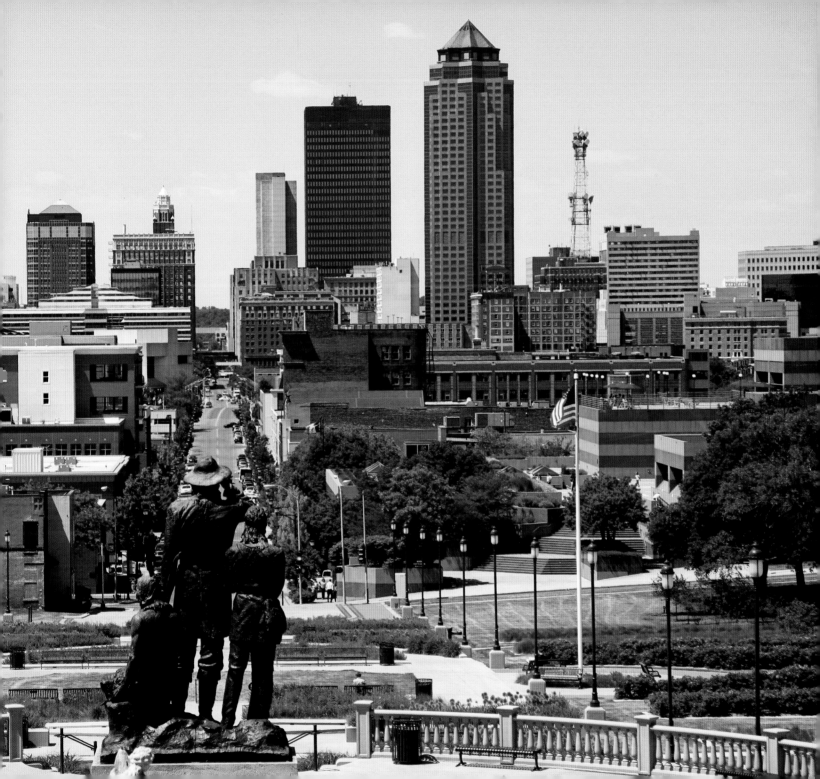

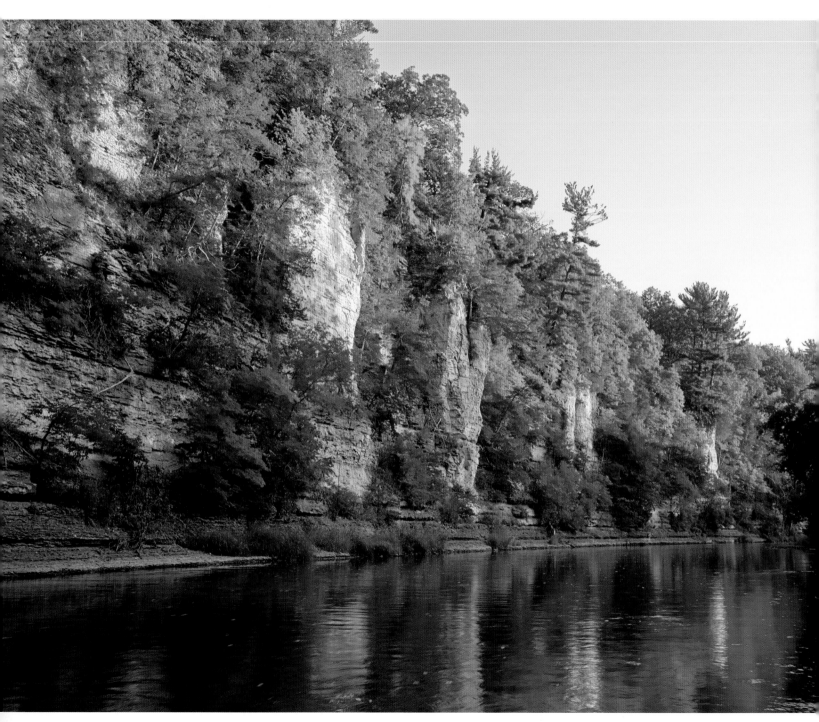

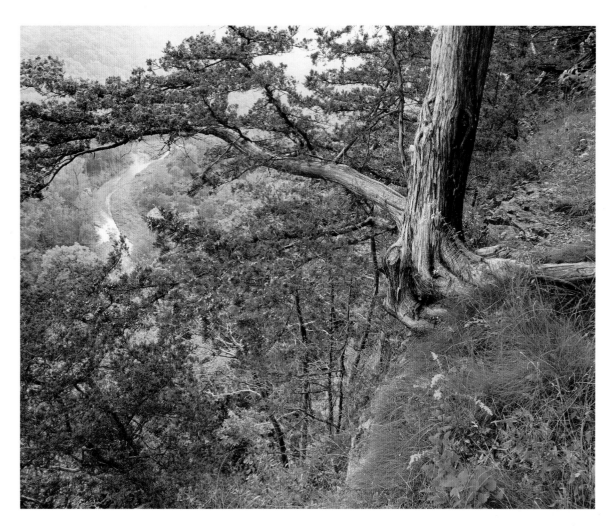

Above: An eastern red cedar clings to a limestone cliff over Big Paint Creek at Paint Creek View in the Paint Creek Unit of Yellow River State Forest. The viewpoint is a steep drive and a short walk off the forest's main road. Clint Farlinger

Right: Lady's slipper orchids are a beautiful but rare component of the Iowa landscape. Clint Farlinger

Left: This section of the Upper Iowa River, between Kendallville and Decorah, contains some of the most stunning scenery in Iowa and is recognized as one of the best places in the country to canoe. Near Bluffton, the sheer limestone bluffs reach heights of 280 feet. Clint Farlinger

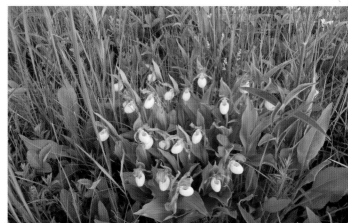

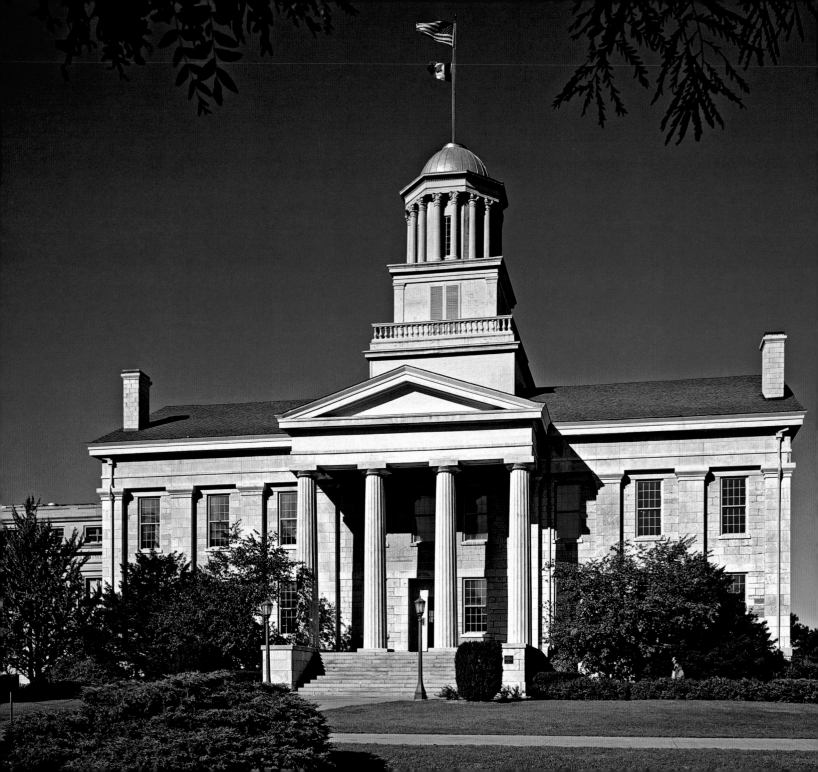

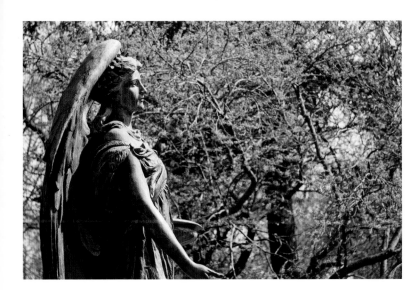

Facing page: The Iowa City landmark Old Capitol originally served as the capitol of the Iowa Territory and then as the first capitol of the new state of Iowa. When the seat of government moved to Des Moines in 1857, Old Capitol became a classroom building at the University of Iowa. Now restored to its early appearance, it houses the Old Capitol Museum. Mike Whye

Left: The bronze statue of an angel at the Ruth Anne Dodge Memorial stands over Fairview Cemetery in Council Bluffs The sculpture, which some call the Black Angel, depicts a figure that Dodge said she saw in dreams three nights before she died in 1916. It was created by Daniel Chester French, artist of the famous Lincoln Memorial statue. Mike Whye

Below: The boyhood home of biologist Dr. Norman Borlaug has been preserved in Howard County, near the town of Protivin. He learned his work ethic on the family farm and obtained his early education in a one-room rural schoolhouse, also preserved on the site. In 1970, Dr. Borlaug was awarded the Nobel Peace Prize for a lifetime of work devoted to feeding a hungry world. Clint Farlinger

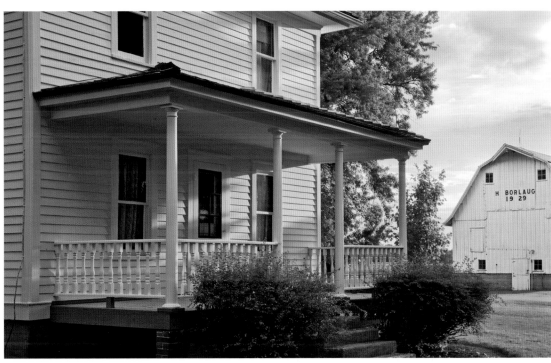

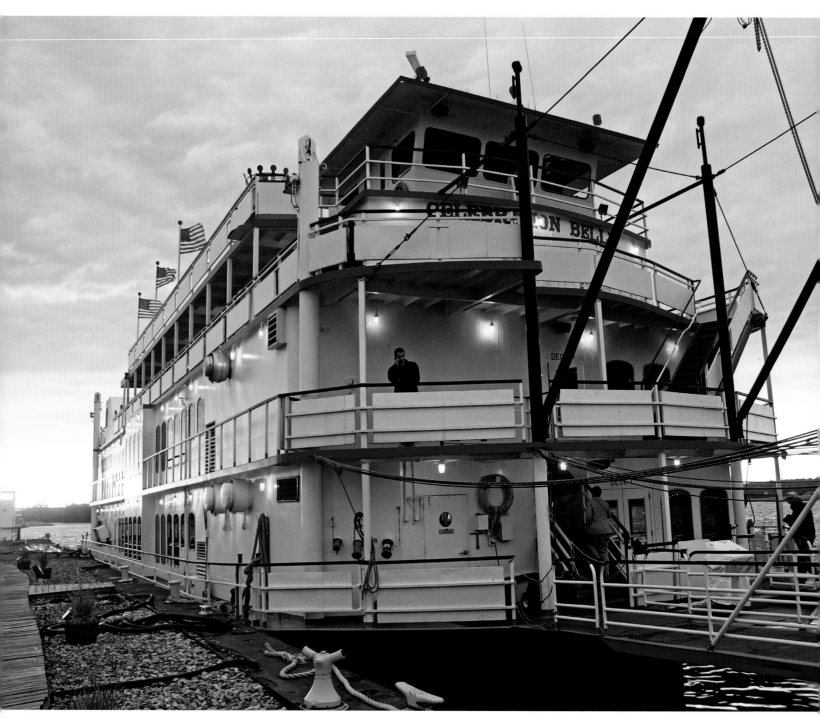

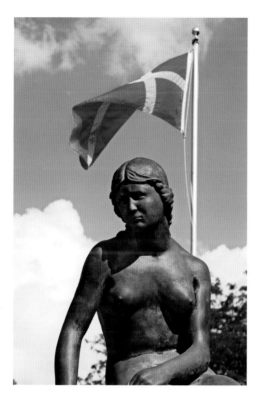

Above: A copy of Copenhagen's famous statue *The Little Mermaid,* by Edvard Eriksen, rests in a fountain in Kimballton. Settled along with the nearby community of Elk Horn by Danish immigrants who began arriving in the mid-nineteenth century, Kimballton is part of the largest rural Danish community in the United States. Mike Whye

Right: Dubuque's Fenelon Place Elevator started in 1882 when a banker built it to travel between his downtown office and his home upon a bluff. Now a commercial operation, the cable cars take visitors along a narrow gauge funicular railway to and from an observation deck overlooking the city. Mike Whye

Left: Based on the Mississippi River in the Quad Cities, the sternwheeler *Celebration Belle* provides a variety of day and overnight cruises among the Iowa cities of Dubuque, Guttenberg, and LeClaire, as well as to cities in Wisconsin and Illinois. Mike Whye

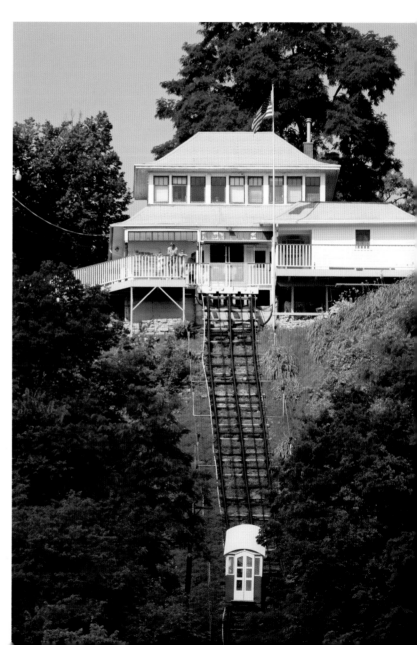

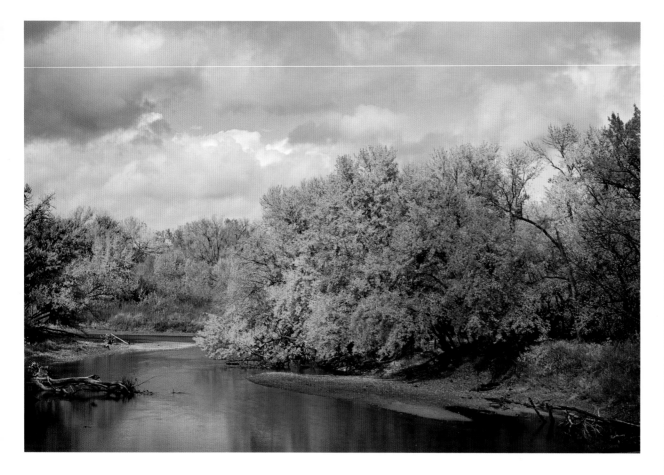

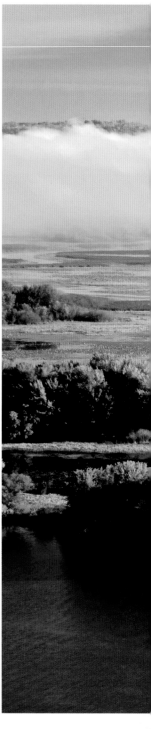

Above: The Big Sioux River, seen here in rural Sioux County, defines the border between Iowa and South Dakota. In Sioux City, it joins the Missouri River to continue its journey toward the Gulf of Mexico. Clint Farlinger

Right: Covered with a forest of maple, basswood, and oak, the bluffs of Bixby State Park and Preserve, north of Edgewood, turn multihued in autumn. The bluffs rise 200 feet above Bear Creek and support a wide variety of microhabitats. Bixby's 184 acres are home to more than 380 native plant species, and are believed to have the greatest diversity of any woodland in Iowa. Clint Farlinger

Far right: Located along the Great River Road, Mount Hosmer City Park in Lansing gives visitors one of the most beautiful views of the Mississippi River in northeastern Iowa. The Great River Road runs for nearly 150 miles along Iowa's "east coast" and showcases the Mississippi River region's unique ecology, history, and culture. Clint Farlinger

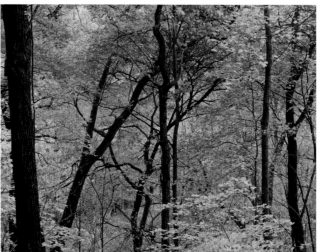

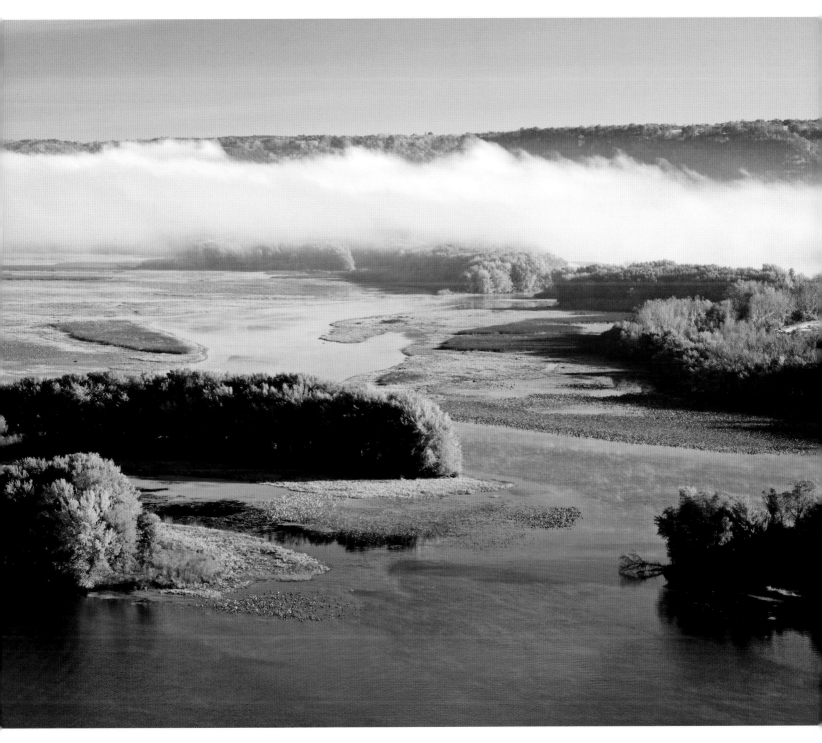

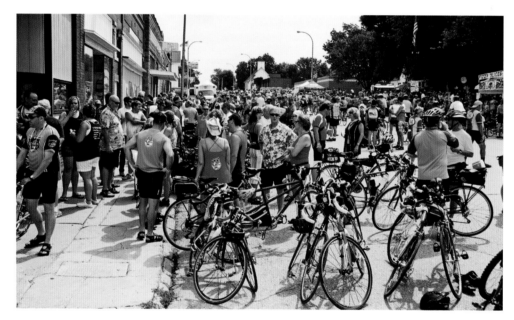

Above, top: The Prairie Farmer Recreation Trail follows the abandoned Milwaukee Railroad line for 20 miles from Cresco to Calmar. This hard-surface trail is open year-round for bikers, walkers, joggers, and even cross-country skiers looking to take in the scenery. Clint Farlinger

Above, bottom: Even a portion of the 10,000 bicyclists taking part in RAGBRAI, the annual bike ride across Iowa, can practically shut down the town of Exira during a lunch stop. The *Des Moines Register* newspaper, which sponsors the event, estimates that RABRAI has visited more than 80 percent of the towns in Iowa since the noncompetitive bicycle outing began in 1973. Mike Whye

Right: Cars with turbocharged engines blast past spectators at Iowa Speedway near Newton. Since opening in 2006, the 7/8-mile oval track has hosted many NASCAR and IndyCar races. Mike Whye

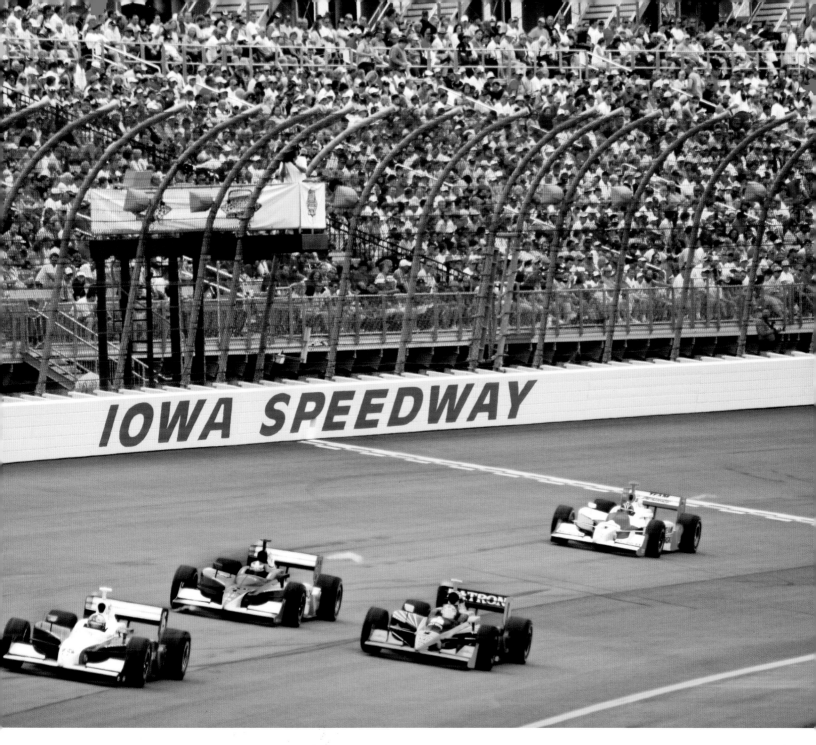

Above: Effigy Mounds National Monument preserves more than 200 burial and ceremonial mounds built 750 to 1,400 years ago by a culture known today as the Moundbuilders. Many mounds are shaped like birds or bears, while other mounds are conical, linear, or some combination. The mounds preserved here are considered sacred, especially to the 18 American Indian tribes associated with the Moundbuilders. The visitor center contains many interpretive exhibits and hosts educational events throughout the year. Clint Farlinger

Right: At the Union Pacific Railroad Museum in Council Bluffs, guests can peruse railroad artifacts, including one of the original four ceremonial railroad spikes used to mark the completion of the first transcontinental railroad in May 1869. Presented by Arizona Territory in honor of the occasion, the spike is made of various metals, including gold and silver. Mike Whye

Far right: Atop a hill east of downtown Des Moines, the Iowa Capitol, completed in 1886, was designed in a refined Renaissance style. Fifteen years were spent building the capitol, which is the only one in the United States to have five domes. Mike Whye

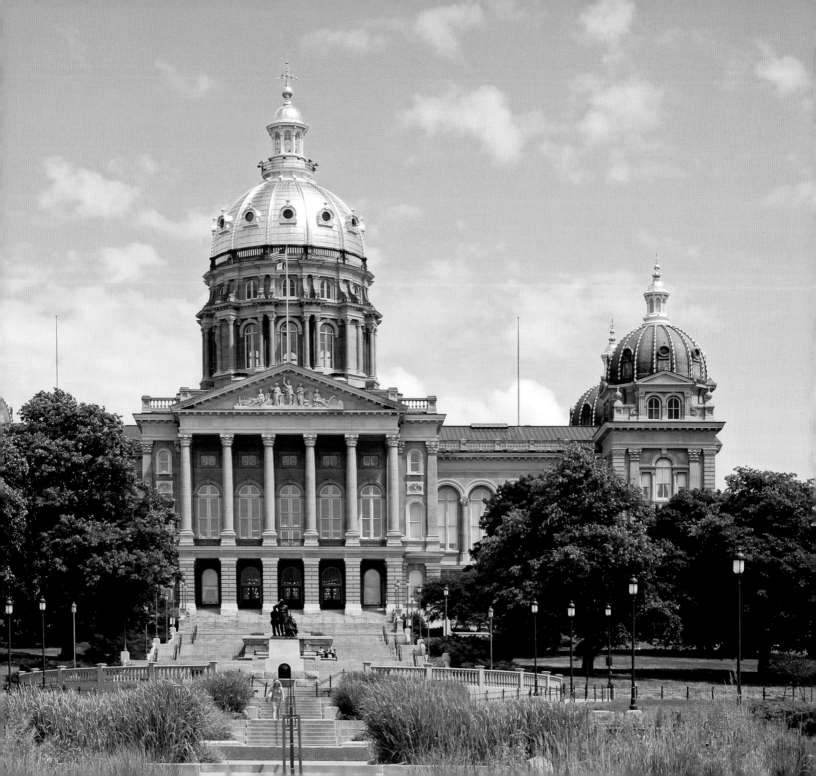

Far right: Hogback Bridge, built in 1884, is one of the 19 covered bridges that once graced Madison County. Covered to protect their plank floors from the weather, the bridges—now just six—became very popular when the novel and movie *The Bridges of Madison County* appeared in the 1990s. Mike Whye

Right: Residents of Elk Horn commemorate their Danish-American heritage during Tivoli Fest, which is celebrated every Memorial Day weekend. The town's iconic windmill overlooks the parade. It was first built in 1848 in Nørre Snede, Denmark, then taken apart and rebuilt in Elk Horn in 1976 as part of the community's bicentennial celebration. Mike Whye

Below: Carrying the flags of the United States, Iowa, Cherokee County, and the Professional Rodeo Cowboys Association, four young flag bearers start off the annual Cherokee Chamber PRCA Rodeo, which began in 1966. Mike Whye

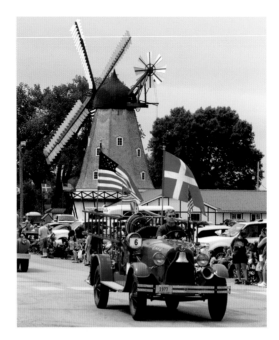

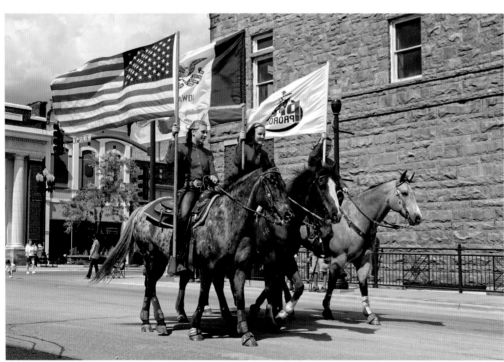

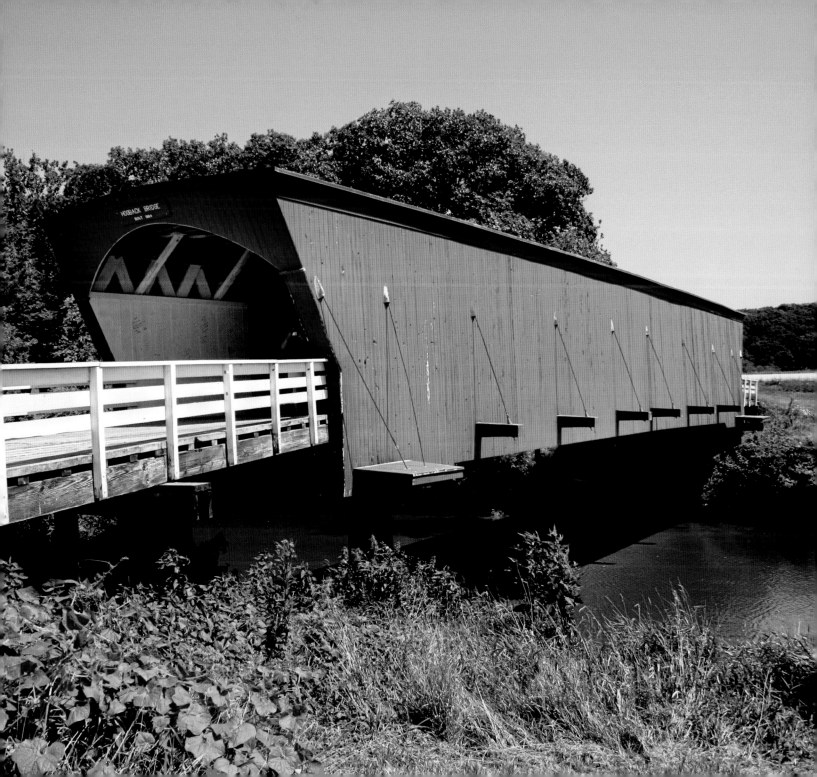

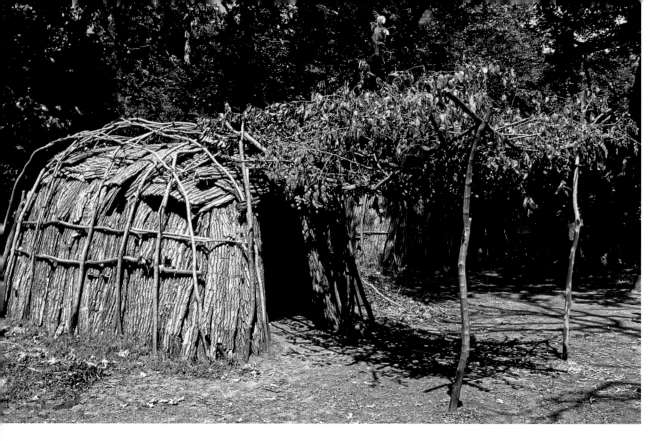

Above: A reproduction of a branch-and-bark lodge used by the Ioway (or Iowa) tribe stands on the grounds of Living History Farms in Urbandale. The Ioway word for such a lodge is *chákirutha*, which means "branches bent to meet." Mike Whye

Right: Fossils up to 375 million years old can be seen in the rocks below the spillway of the Coralville Dam near Iowa City. Floods in 1993 and 2008 exposed the fossils in what is now called the Devonian Fossil Gorge. Visitors may examine the fossils from this area, but not collect them. Mike Whye

Far right: A temporary exhibit at the entrance to the Davenport's Figge Art Museum, *Driftwood Wave* was made of three tons of driftwood found along the nearby Mississippi River by artists Chris Fennell and Mark Fowler. The Figge's distinctive building opened in 2005 to house works by international creators and noted Iowan artists such as Grant Wood. Mike Whye

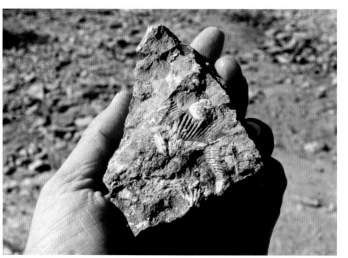

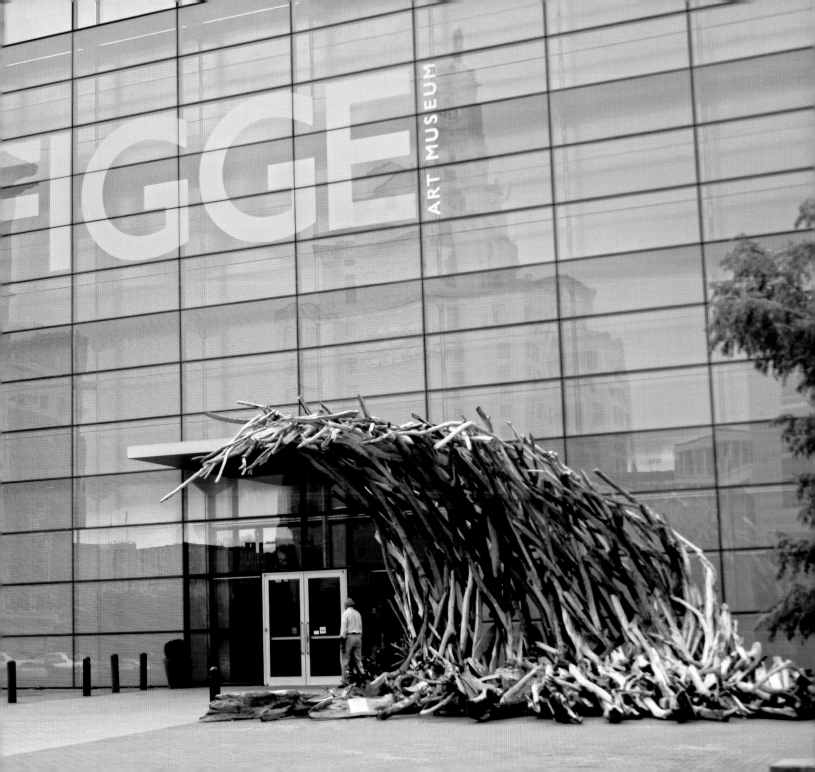

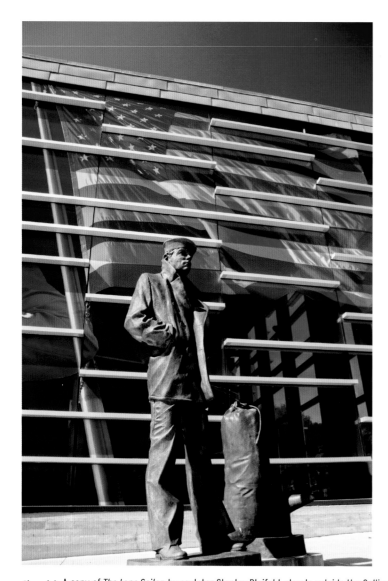
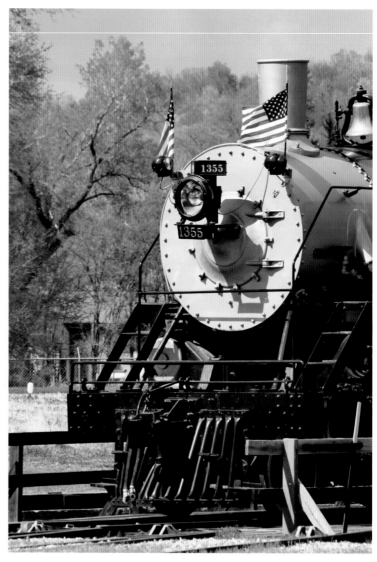

Above, left: A copy of *The Lone Sailor*, by sculptor Stanley Bleifeld, stands outside the Sullivan Brothers Iowa Veterans Museum in Waterloo. Honoring Iowans in all services, the museum is named after brothers George, Francis, Joseph, Madison, and Albert Sullivan, who died when the USS *Juneau* sank in World War II. Mike Whye

Above, right: Built in 1909, this steam locomotive was operated by Great Northern Railway until its 1955 retirement. Now at the Railroad Museum of Sioux City, it's stored in a roundhouse once operated by the Milwaukee Railroad. GN1355's seven-chime steam whistle makes a unique sound still heard on special occasions. Mike Whye

Facing page: The symbol of America waves proudly from this grain bin along the River Bluffs Scenic Byway in Clayton County. Clint Farlinger

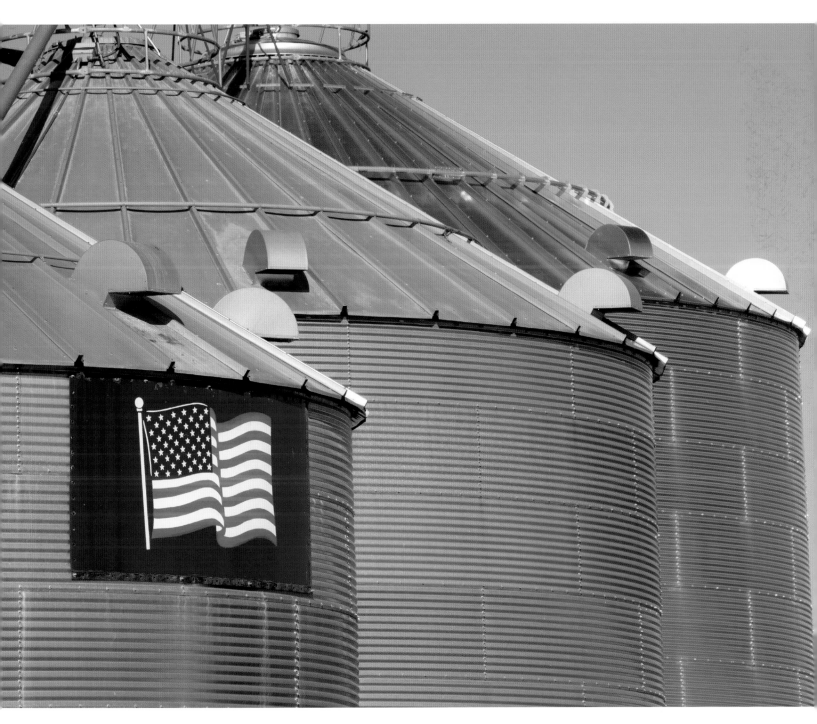

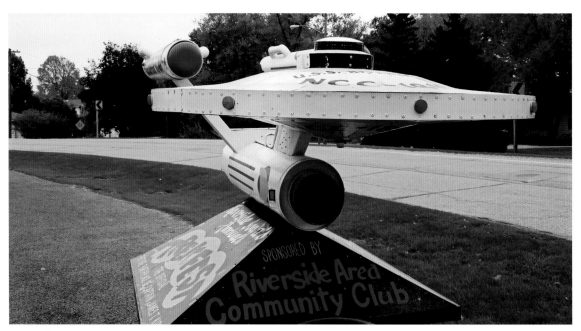

Above, top: Sunflowers bloom in Yellow River State Forest near Harpers Ferry. Clint Farlinger

Above, bottom: The starship *Riverside*, a sister ship of the starship *Enterprise* of Star Trek television series and movie fame, is moored in Riverside in eastern Iowa. According to Star Trek lore, the *Enterprise's* future captain, James T. Kirk, will be born in Riverside on March 22, 2233. Mike Whye

Right: An untitled sculpture of three colorful dancers, designed by Keith Haring, is one of more than two dozen sculptures in downtown Des Moines' John and Mary Pappajohn Sculpture Garden, which is run by the Des Moines Art Center. Mike Whye

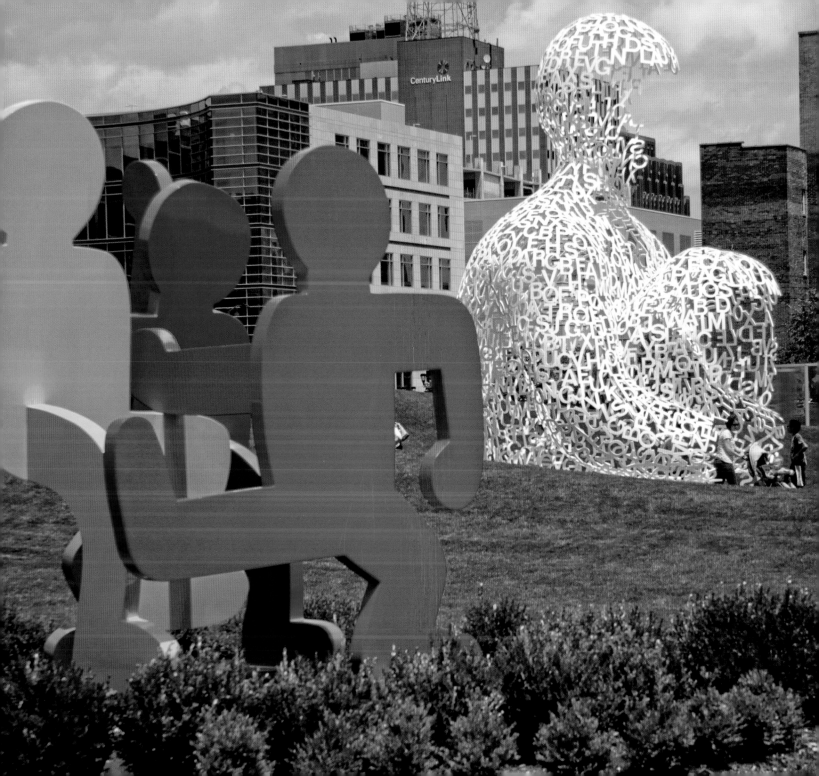

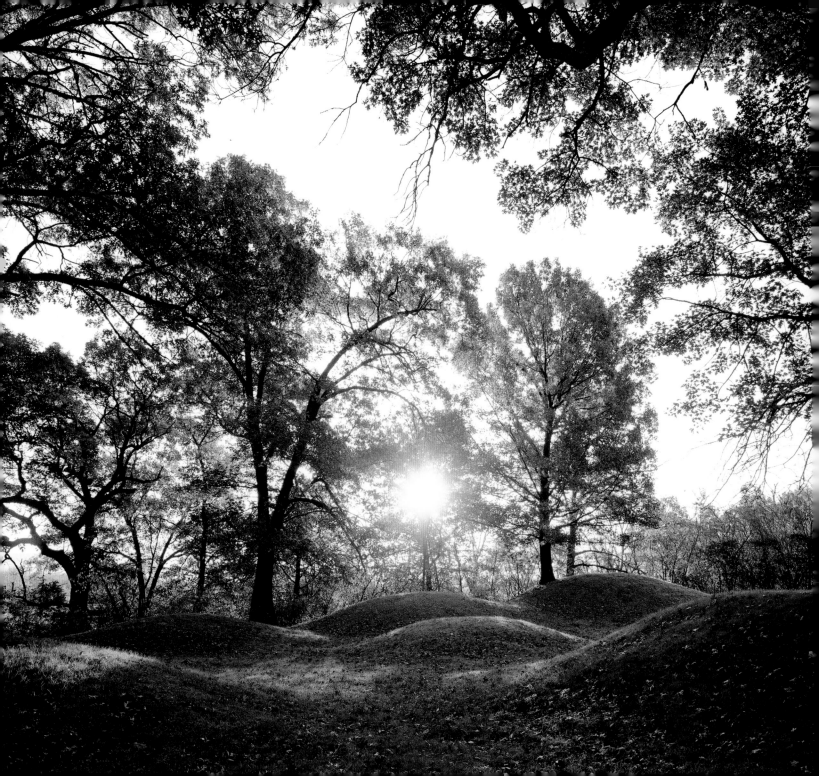

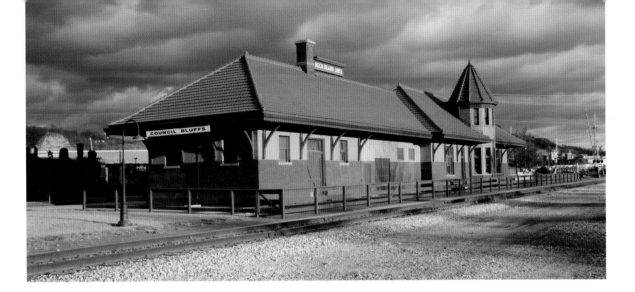

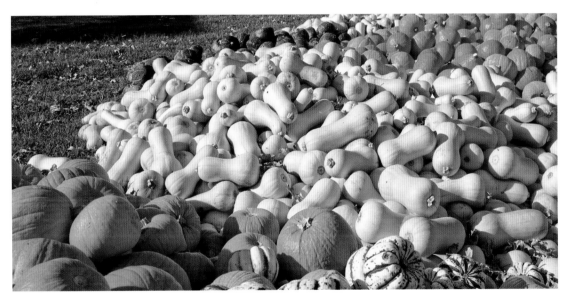

Above, top: The last of eight passenger depots that once stood in Council Bluffs, the Rock Island Depot now serves as the RailsWest Railroad Museum, which covers the importance of railroading in the city. Council Bluffs was once the nation's fifth-largest mail terminal due to the abundance of mail trains moving through here, and today the RailsWest Museum, Union Pacific Railroad Museum, Golden Spike monument, and Historic General Dodge House make Council Bluffs a top destination for railroad enthusiasts. Mike Whye

Above, bottom: A bountiful harvest of pumpkins and squash fill an Amish farmer's yard in northern Howard County. Clint Farlinger

Left: The morning sun shines through trees surrounding a few of the 30 conical burial mounds at Fish Farm Mounds State Preserve in Allamakee County. The name of the preserve comes from a family that donated part of its farmland to the state to preserve the mounds, which are believed to have been constructed between 100 B.C. and 650 A.D. Mike Whye

Above: Virginia bluebells and anemone carpet the forest floor in early spring at Vernon Springs County Park by the Turkey River. Clint Farlinger

Right: Yucca is generally associated with drier states farther west, but it is quite at home in the prairies of the Loess Hills. Many specimens can be seen blooming in Loess Hills State Forest, Harrison County, near Pisgah. Clint Farlinger

Far right: Thunderstorms are a common occurrence during a typical Iowa summer. Three basic ingredients are needed to produce a thunderstorm: moisture, an unstable atmosphere (such as when cold air sits above warm air), and the lifting of surface air (as can be caused by an approaching cold front). These conditions all came together over Mike Zach Wildlife Area just south of Mason City. Clint Farlinger

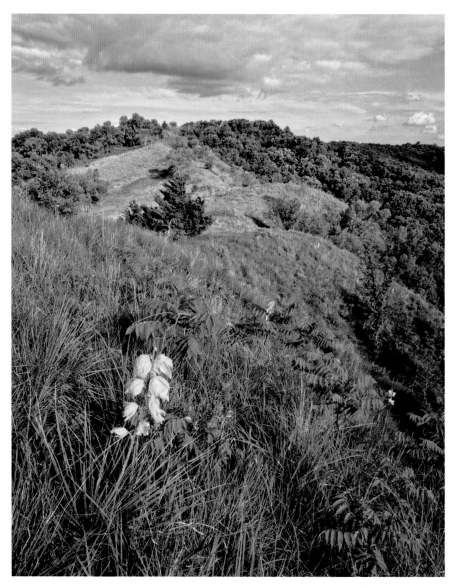

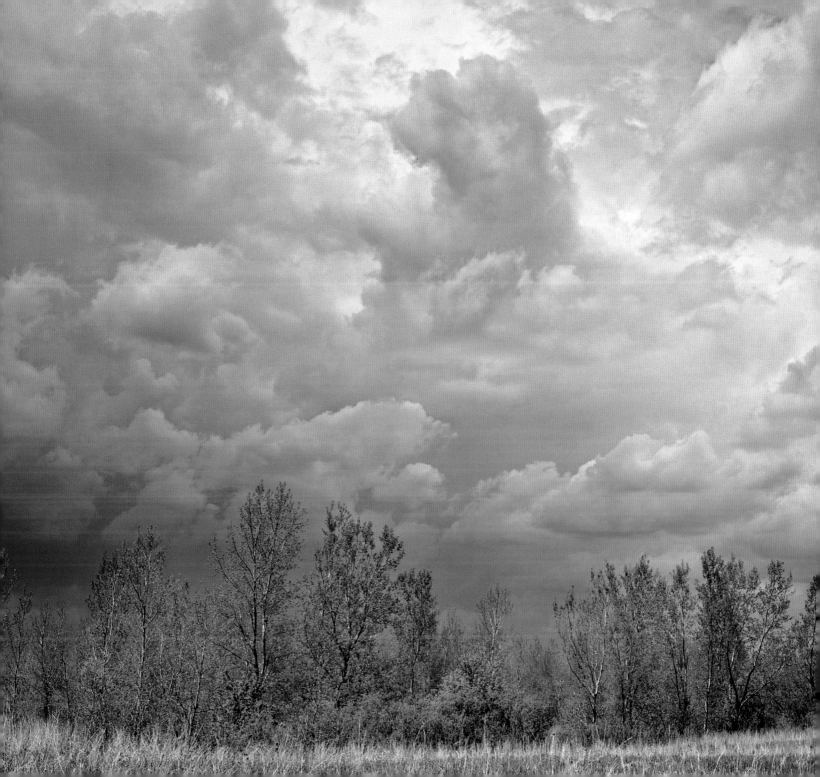

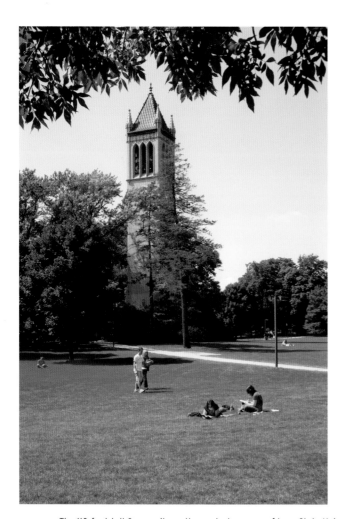

Above, left: The 110-foot-tall Campanile on the central campus of Iowa State University houses the 50-bell Stanton Memorial Carillon, which plays every quarter hour. Tradition has it that no one is a real Iowa State student until they have been kissed under the Campanile at midnight. Mike Whye

Above, right: The charming Episcopal Church of the Saviour, Clermont, was built in 1867 as a gift from Frances Vinton of Providence, Rhode Island, in memory of a son and daughter who died in their youth. She chose Clermont because she believed it to be the geographical center of the United States. Clint Farlinger

Right: Located in Wildcat Den State Park, Pine Creek Grist Mill, a beautifully preserved, mid-nineteenth century mill is listed on the National Register of Historic Places. Benjamin Nye, an early settler of Muscatine County, built it in 1848. Clint Farlinger

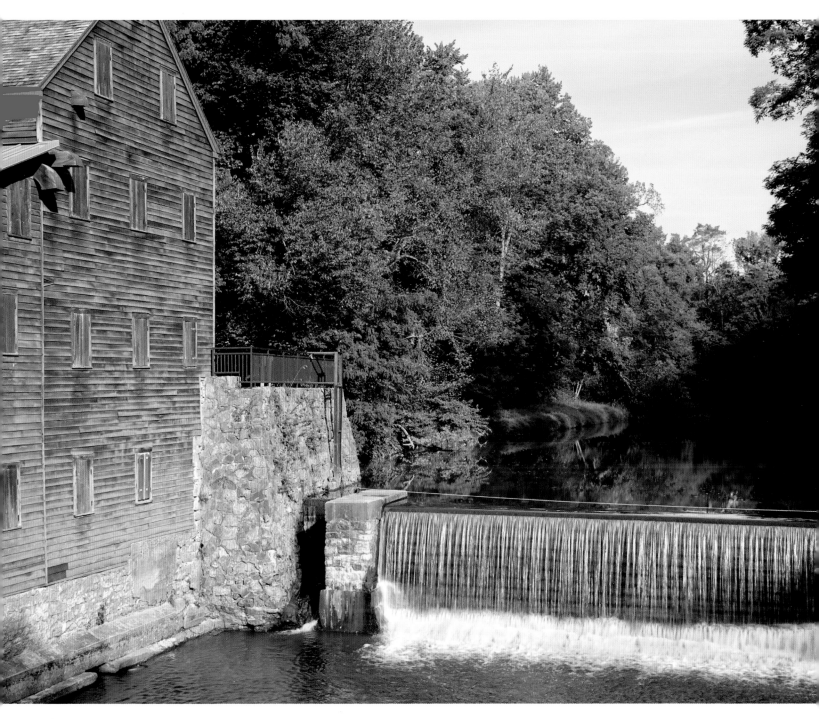

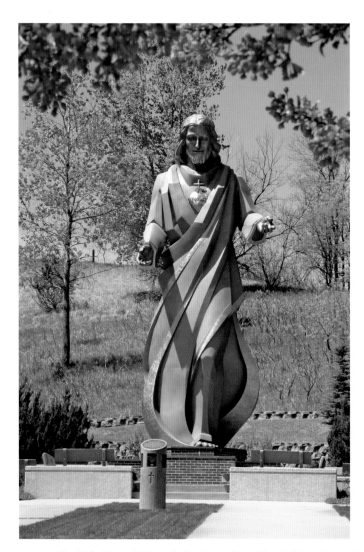

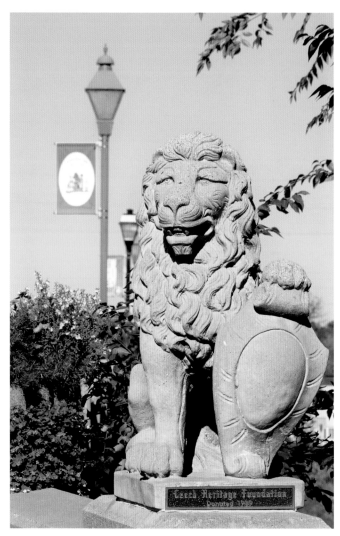

Above, left: The 33-foot-high stainless steel sculpture *Sacred Heart of Jesus* stands at one end of the grounds at Trinity Heights, a religious site on the north side of Sioux City. Mike Whye

Above, right: The 16th Avenue Bridge, a landmark of Cedar Rapids' Czech Village and New Bohemia district, is guarded by stone lions that reflect the Czech and Slovak heritage of about 20 percent of the city's population. Mike Whye

Right: Built in the 1880s by wealthy widow Caroline Soutter Sinclair for her family of six children, Brucemore served as an elegant Cedar Rapids residence to the Sinclairs and two other families before it was donated to the National Trust for Historic Preservation. The mansion boasts beautiful period furniture and a Grant Wood-designed sleeping porch. Mike Whye

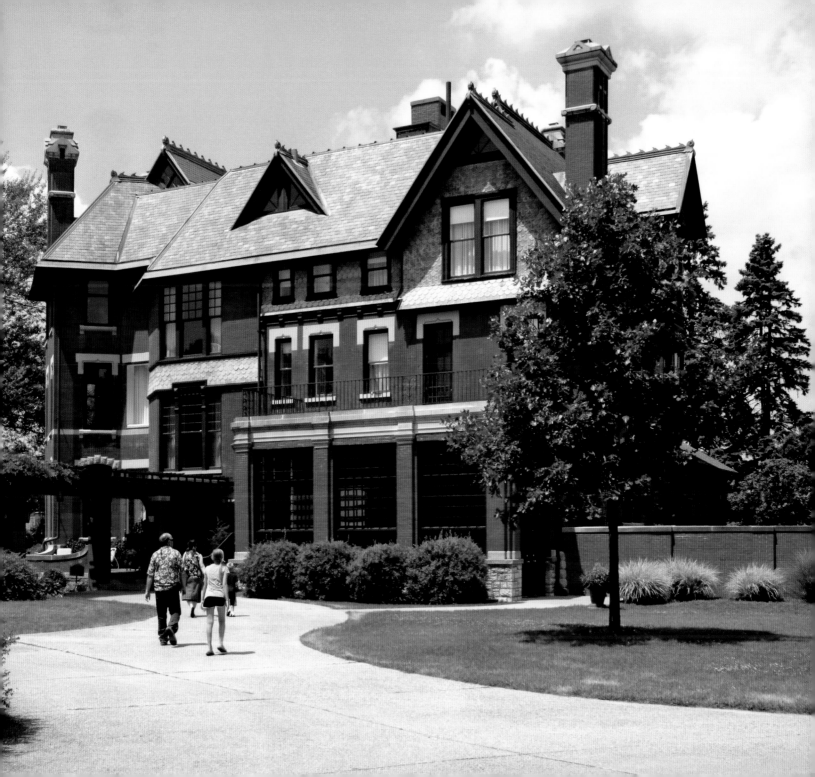

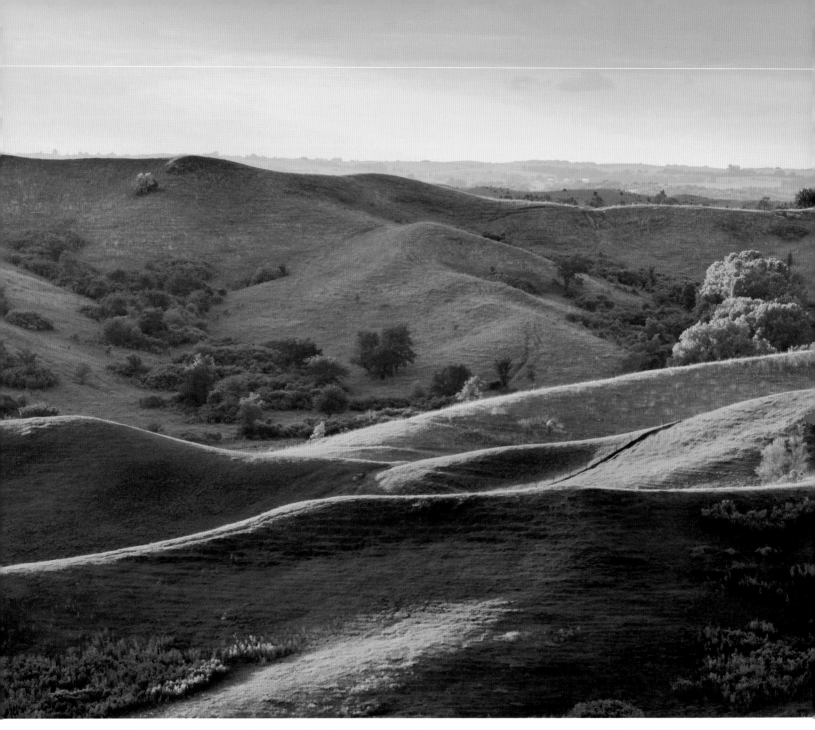

Broken Kettle Grasslands Preserve, in Plymouth County, is home to Iowa's largest remaining native prairie and stunning views of the Loess Hills. Clint Farlinger

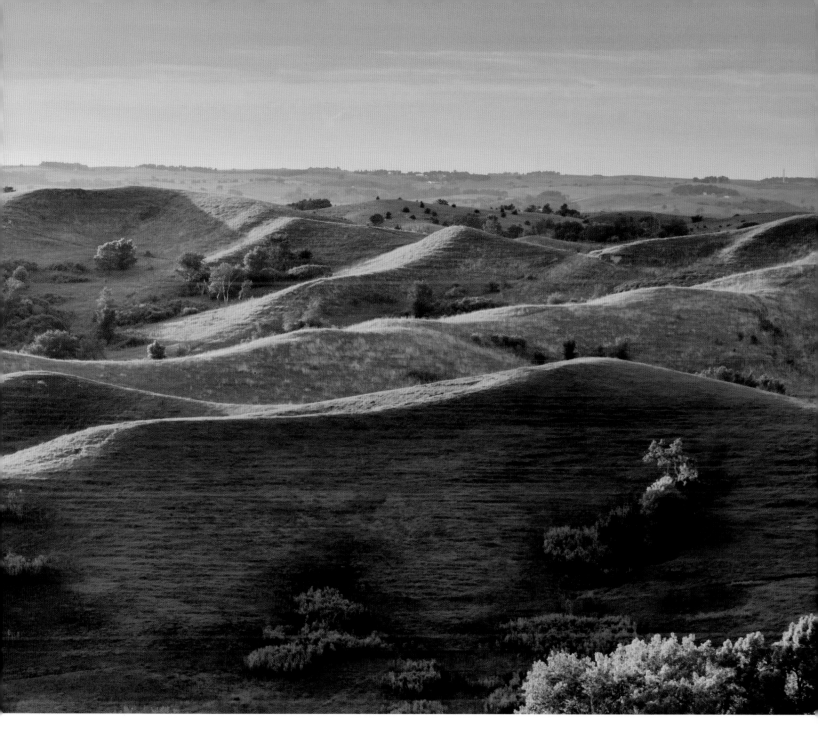

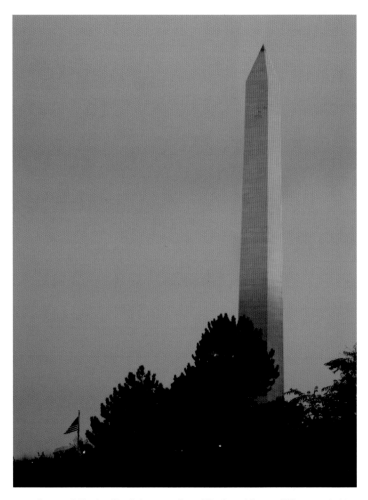

Above: Sergeant Charles Floyd, Jr., a member of the famed Corps of Discovery led by Captains Lewis and Clark, was buried near this obelisk south of present-day Sioux City on August 20, 1804. Amazingly, Floyd was the only member of expedition to succumb during its 28-month-long exploration of the lands west of the Mississippi. Mike Whye

Right: Altocumulus clouds light up colorfully over Little Spirit Lake shortly before sunrise. Little Spirit Lake is shallow, with a maximum depth of less than ten feet, but anglers and boaters will find that it makes for a perfect Iowa day. Clint Farlinger

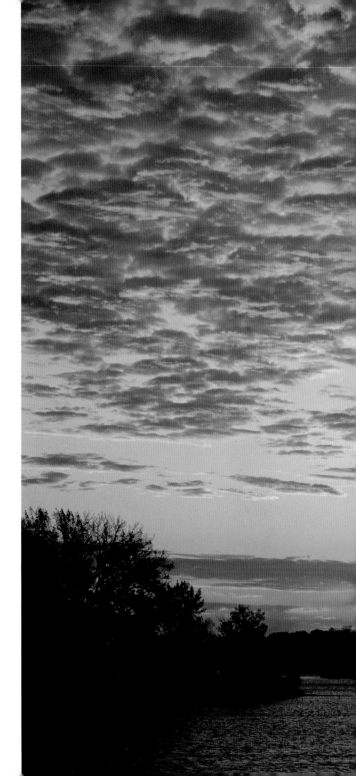

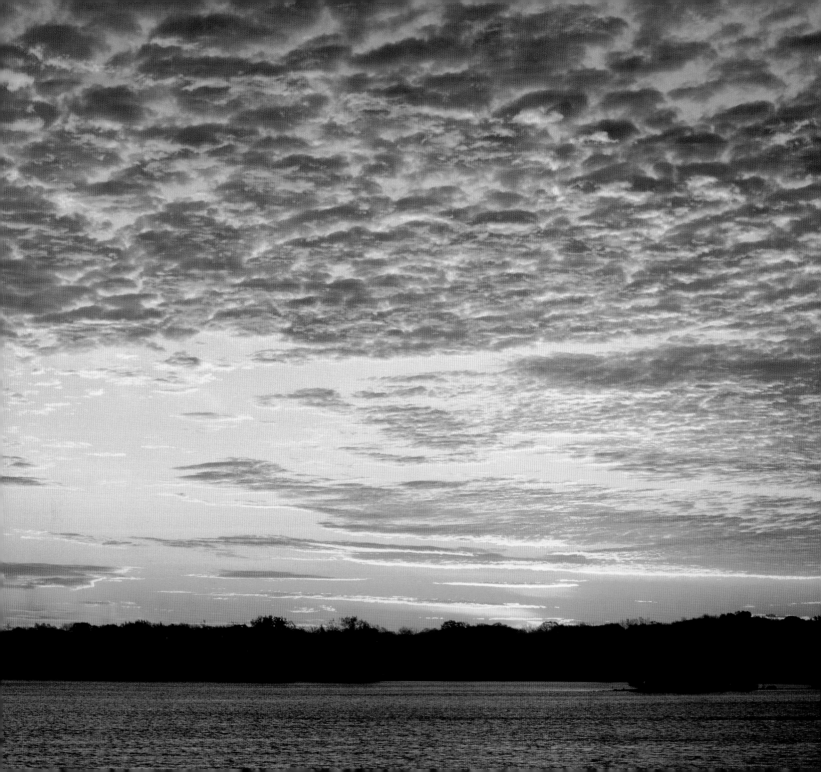

CLINT FARLINGER, a professional photographer since 1992, photographs nature's beauty extensively in the Midwest as well as throughout the world. Through careful use of light and composition, he creates images that are both artful and illustrative of nature's story. He has years of experience working on-assignment for magazines such as *Midwest Living* and writing for magazines including *Outdoor Photographer, Sierra,* and *Shutterbug.* In addition to these magazines, he has a vast array of credits including National Geographic books and calendars, *National Parks* magazine, BrownTrout calendars (including several containing only his images) and numerous other books, magazines, and calendars. See Clint's work at www.farlingerphoto.com.

MIKE WHYE developed his love of travel from when he was an Air Force brat. As a freelance writer-photographer, he has been writing and photographing articles for newspapers, magazines, and private, public, and government entities since 1984. Mike has won the top Mark Twain Award for excellence in photojournalism four times from the Midwest Travel Writers Association, and also teaches photography and journalism at the University of Nebraska at Omaha. He resides in Council Bluffs, Iowa. For more on Mike's work, visit mwhye.home.radiks.net.